AMERICAN IMPRESSIONIST
MASTERPIECES

AMERICAN IMPRESSIONIST

MASTERPIECES

Lisa N. Peters

HUGH LAUTER LEVIN ASSOCIATES, INC.

Distributed by Macmillan Publishing Company
New York

A Harkavy Press Book

ISBN 0-88363-800-2

Color separations by Excel Graphic Arts Company

Printed and bound in Hong Kong by Leefung-Asco Printers Limited

Contents

Acknowledgments

No study of American Impressionism can be without a debt to Professor William H. Gerdts, as his 1984 book and his other publications are the basis for any explorations of the subject. The groundwork he has laid makes this volume possible, and his library was an invaluable source of information. I am also grateful to Ira Spanierman for his help with the selection of works in this book and the insights on American Impressionism that he has shared with me. In preparing the essays, I consulted the works of a considerable number of scholars. Although not all can be listed here, I would like to acknowledge the insight and information I received from the recent writings of Doreen Bolger, Richard J. Boyle, Nicolai Cikovsky, Jr., David Park Curry, Elizabeth de Veer, Ilene Susan Fort, John Douglass Hale, Susan Hobbs, Sona Johnston, Nancy Mowll Mathews, Ronald G. Pisano, and H. Barbara Weinberg. I am additionally very appreciative to Dale Ramsey for his skillful and graceful editing, to Lucy Barber for organizing this book's photographic material, to Jeffrey R. Brown, Kathryn Corbin, David C. Henry, Richard H. Love, Meredith Long, Jenny Long Murphy, Anne Schmoll, and Robert C. Vose III, for assistance in obtaining reproductions, to Carol Lowrey for her consultation, and to the museum staff members and individuals who granted permission for the inclusion of works. Finally, I would like to express my thanks to my family for their constant encouragement and support.

LISA N. PETERS

Impressionism on the Rise in America

*I*n May of 1893, the American Art Galleries in New York hosted two simultaneous exhibitions, one featuring works by American painters J. Alden Weir and John Henry Twachtman, and the other presenting paintings by Claude Monet. Although the shows were mounted separately, the critics considered them together in their reviews, concurring with the *New York Times* writer who noted that the display was "a treat for the apostles of light and air and the hot vibrations of sunlight in painting. . . . It is also a fine opportunity to compare with the works of Monet, the most conspicuous of Parisian impressionists, those of two of our own most advanced followers in his footsteps."

By the early 1890s, Impressionism had come to America, where it was embraced by artists, widely accepted by critics, and popular with collectors and the public. Its rise to prominence had been rapid; just a short time earlier the French movement had been either misunderstood or held in derision by Americans. Even Weir had become a convert only a couple of years before the 1893 show. In Paris in 1877, he had been a visitor to the third French Impressionist exhibition, an experience that repelled him. He wrote to his parents, "I never in my life saw more horrible things. . . . They do not observe drawing nor form, but give you an impression of what they call nature. It was worse than the Chamber of Horrors."

Weir was part of the wave of Americans who went to Europe to study art in the post–Civil War period, but Impressionism would not be on his agenda, or on that of most of his compatriots abroad or at home, until late in the nineteenth century. In the decades before the Civil War, artists had concentrated on defining the national identity in their art. After the war a new consciousness arose. The panoramic pastoral and wilderness scenes that had been rendered from the 1820s through the 1850s by Thomas Cole, Asher B. Durand, Albert Bierstadt, and Frederic Church, had conveyed a patriotic, even didactic, message. These works suddenly seemed outdated, as did the detailed, literal, transcriptive style practiced by this established old guard. Young painters, rebelling against what they saw as an insular aesthetic tradition, sought to create an art of international stature. While Americans had always derived inspiration from European art, they were now incited by a new cosmopolitan spirit to find a more direct link with international trends. Their goal was to assimilate the achievements of European artists and to establish an art that would equal and surpass theirs. For great numbers of Americans, France was the country to which they turned, and it was French art that would be the principal influence on American painting for the rest of the century.

The 1860s saw the beginning of the exodus of Americans seeking training abroad, particularly in Paris. While some, such as the Philadelphia painter Thomas Eakins, received a thoroughly traditional education in the French capital during that decade, others became proponents of the French Barbizon school, which had developed around the middle of the

century. Influenced by that movement, which included Jean-François Millet, Camille Corot, and Charles Daubigny, painters such as William Morris Hunt, George Inness, and Albert Pinkham Ryder executed intimate forest scenes that emphasized moody atmospheric qualities but omitted the social issues that had concerned the Barbizon group. By the 1870s, it was deemed mandatory for a young painter from the United States to have firsthand exposure to the art of Europe. Scores of Americans took up residence in Paris, enrolling in academies and ateliers where they could receive private instruction. It was during these same years that the French establishment was being challenged by the artists who became known as the Impressionists.

Edouard Manet had initiated the revolution in the 1860s, showing works that broke from the canons of acceptable subject matter and stylistic treatment. By the early 1870s the progressive painters Claude Monet, Camille Pissarro, Alfred Sisley, Edgar Degas, and Auguste Renoir were following his lead, breaking the rules of pictorial representation. They rejected the idealized and archaic motifs rendered by academic artists and drew their inspiration from everyday life. They painted views of avenues and cafés and presumably taboo images of high- and low-life Paris, exposing a society caught up with leisure and glamour in a vortex of urban activity.

Rendering landscapes, they freed themselves from dark studios to work in the open air. Eschewing dramatic sites dotted with ruins—the favored subject of the eighteenth-century painters Claude Lorrain and Nicholas Poussin—they often revealed signs of modern civilization intruding on the countryside. Their primary concern was the representation of sunlight. Whereas academic painters avoided strong luminous effects, the Impressionists welcomed them. Their new vision required a new technique. They eliminated black from their palettes and employed pure, unmixed colors to convey the impact of sunlight on natural forms. Instead of gradual shifts of tone, they juxtaposed strong colors to create jarring contrasts and shimmering optical results. Rejecting the traditional method of building up forms from dark to light, they captured the effects of shifting light upon forms by the layering of contrasting colors. Instead of creating highly polished picture surfaces like those of academic

artists, they painted in vigorous, varied brushstrokes that conveyed the ephemerality of nature. When seen from a few yards away, their dabs of pigment appear to blend together; in their canvases the viewer finds rainbow-colored reflections as well as subtle color variations within shadows.

The Impressionists also established a new treatment of pictorial space. They abandoned the system of perspective established in the Renaissance, a diagrammatic plotting of the diminishing scale of objects receding in a picture's distance. Instead, they transcribed relations between forms as they directly perceived them and thus allowed odd juxtapositions. Instead of setting motifs within the pictorial depths, the Impressionists presented them in the foreground, often cropped or seeming to propel themselves into the viewer's arena. A resultant flattening of space, in and of itself, became a signature of Impressionist art; the new representation of pictorial space was expressive of the modern era, conveying its immediacy, its new urgency, tension, and rapid pace. To break from conventional formulas, the Impressionists turned to photography and Japanese art, finding in these sources innovative ways of arranging forms on canvas.

Seen as radicals, the French Impressionists were disdained when they displayed their work in Paris in the 1870s and 1880s. The artists held their first show in 1874, exhibiting as the "Société Anonyme." A critic coined the word "Impressionism" on seeing Monet's *Impression: Sunrise* in the display, and their art soon became widely identified by this term. At first, most of the countless American students in Paris either rejected Impressionism or were relatively unaffected by it. The one exception was Mary Cassatt, who belonged to the French Impressionists' milieu rather than to that of her compatriots. The only American to exhibit with the French Impressionists, Cassatt lived in France from 1872 on. She persuaded a number of important American patrons to purchase French works, and a few of her canvases were exhibited in the United States, but her art had little impact there. Winslow Homer is another artist who may have had early exposure to French Impressionism. In France from 1866 to 1867, Homer may have seen works by Manet and Degas, and the paintings he created on his return, such as his depictions of women playing croquet, pose questions of foreign influence.

However, Homer never became a proponent of the French style, and his symbolic art veered away from Impressionism as his career progressed. Others exposed to French Impressionism during the 1870s were opposed to the style. Though influenced by French Barbizon paintings, George Inness was one of the most outspoken adversaries of Impressionism, condemning the new movement as "sloth enrapt in its own eternal dullness." Weir's response, already mentioned, was typical of the stance of many Americans abroad and at home.

In fact, Weir's reaction in 1877 is understandable given that he was then a student at the Ecole des Beaux-Arts under the conservative Jean-Léon Gérôme. Americans studying in Paris may have initially felt a sense of betrayal upon encountering Impressionist works. In the academies, they were drawing from casts and gradually working their way up to rendering the figure from life, attaining skills in draftsmanship and perspective that would eventually allow them to create large-scale, multifigured compositions. They were learning how to model forms and to render atmosphere through a gradual shifting of tones. American students had come abroad to learn to paint as the Old Masters had, and the Impressionists broke the very rules that they were busily assimilating.

It was not until the mid-1880s that the attitudes of American artists changed, but a number of developments in the 1870s laid the groundwork for the broad acceptance of the French style in the United States. During this decade, as noted, more American art students than ever congregated in Paris; yet a large number went to Munich, an extremely vital art center. At the Munich Royal Academy, which offered a traditional curriculum, they came into contact with the innovations of Wilhelm Leibl, a German follower of Gustave Courbet. Frank Duveneck, the leading American exponent of Leibl's style, encouraged a large circle of colleagues to create works *alla prima*, rendering canvases all at once in a dark, dramatic, bravura style. In America, a showcase for the works of young artists trained in Munich, as well as in Paris, was provided by the Society of American Artists, established in 1877 by a group of progressives who broke away from the conservative National Academy of Design, the main exhibiting forum since the 1820s. When paintings by Duveneck, as well as other

Munich-trained artists, such as William Merritt Chase, John Henry Twachtman, Joseph DeCamp, and Theodore Wendel, were shown in the society's exhibitions in the late 1870s, their novelty was duly noted. Indeed, it was at this time that American critics began to use the term "Impressionism," applying it, albeit mistakenly, to any canvases that revealed a sketchiness or freely expressive handling.

The works of Munich-trained artists represent the most obvious evidence of progressive trends in America in the post–Civil War period. Another arena for change was quietly developing as artists grew increasingly interested in secondary media. The American Watercolor Society was founded in 1866, and over the next two decades artists explored the potential of watercolor for a brilliant range of translucent effects. In the early 1880s, the interest in pastels, which had begun in France, spread to America. The pastel medium, comprising powdered pigments mixed with binding materials and molded into chalk sticks, offered artists an opportunity to capture fleeting color impressions and a variety of textures similar to those attainable in oils. Requiring few materials, which could be used with spontaneity and in the outdoors, pastels were perfectly suited to the methods and expressive concerns of Impressionism. Among the French, Degas, Manet, Cassatt, and Berthe Morisot used pastel extensively, delighting in its dual capacity for draftsmanship and painterly effects. In America, Chase led the pastel revival, conceiving the idea for the Society of Painters in Pastel, a group that exhibited from 1884 to 1890. The fresh color and directness of the medium encouraged Chase and others to adapt pastel techniques to oil painting, which led directly to the formulation of their Impressionist approaches.

Thus, when French Impressionist painting began to appear in America in the mid-1880s, artists and critics alike had been accustomed to novelties of the sort that spurred their appreciation of the movement. The seminal show of French Impressionist works in America was held in the spring of 1886, in New York, at the Durand-Ruel Galleries, whose owner was the proprietor of a Parisian gallery of the same name. That exhibition of almost three hundred canvases met with mixed responses. While a *New York Times* reviewer accused Monet, Renoir, and others of

indulging in "orgies of drawing and color" and of creating "dreadful examples of polychromatic dissipation," other, more positive critics made a sincere effort to understand the new movement. The *Studio* reported:

The way to look at the true impressionists then, at Claude Monet, at Renoir, at Sisley, Pissarro, Degas, and the rest, is, to regard them as men who are honestly bent on seeing things with their own eyes, and are trying the experiment of painting them by any method that will give back the effects they see. . . . In the work of the true impressionist, not only must the thing be painted from life, and wholly out of doors, if it be a landscape, but it must be painted at once, and finished then and there. We cannot accept as an impressionist picture, one that has been worked over, or warmed over.

The 1886 exhibition was an immediate success, and many of the works were quickly purchased by American patrons. Durand-Ruel reported later that "without America, I was lost, ruined, through having bought so many Monets and Renoirs. . . . The American public does not laugh, it buys." In the years following the exhibition, Impressionism spread rapidly in America. The *New York Times* reported:

The growth of what are called in France the Impressionists would be sufficiently interesting of itself, though art in America remained absolutely unaffected by the movement. But it happens that we are assailed by them from two directions. Certain dealers in the fine arts . . . have been importing the works of the chiefs of the new school . . . while many of our young painters who have studied their profession in Paris have returned to this country inspired by the belief that in Impressionism art has wrested from nature a great many aspects hardly suspected by the old and later masters of the craft.

The American movement was indeed fueled by a number of artists who had come into direct contact with Claude Monet. In the summer of 1887, a small band of Americans came upon the village of Giverny in Normandy. According to their later recollections, they did not know at first of the presence of Monet, a resident since 1883. But soon the American *Givernois* were using the bright palette and animated brushwork of the Frenchman. The *Art Amateur* reported in October, 1887: "Quite an American colony has gathered . . . at Giverny . . . these men . . . have got the blue-green color of Monet's Impressionism and 'got it bad.'" Their works were seen in Boston and New York, and soon they too had followers among their colleagues at home. The *Art Amateur* stated in 1891 that

curious paintings by young Bostonian disciples of Monet, or Manet, with unconventional, prismatic reddish hues for fields and trees, and streets and houses in pinks and yellows respectively, have appeared from time to time for a year or two. . . . Mr. Foxcroft Cole imports a number of Monets for collectors of authority [and] Mr. Vonnoh returns imbued with the new style, and backs it with earnest work and intelligent reasons.

The appreciation of the movement now extended to young artists coming to the fore as well as to artists who had previously resisted the style, such as Weir. Not all American artists became instant Impressionist converts, but colorful, vibrant canvases soon held a primary position in important annual exhibitions throughout the country. At the World's Columbian Exposition, held in Chicago in 1893, American Impressionist works, though only a part of the display of native art, commanded the attention of the crowds and were the focus of critics' bulletins. As the writer Hamlin Garland noted on attending the Exposition:

Every competent observer who passed through the art palace at the exposition was probably made aware of the immense growth of impressionistic or open-air painting. If the Exposition had been held five years ago, scarcely a trace of blue shadow idea would have been seen outside the work of Claude Monet, Pissarro, and a few others.

By the mid-1890s, articles on Impressionist technique began to appear in American art journals. *Scribner's* carried a commentary in 1896 on the principle that colored light casts its complementary color in shadow, explaining, "A yellow sunset will throw blue shadows upon snow, but a red sunset will throw green shadows, and a greenish-yellow sunset violet shadows."

The founding of the Ten American Painters in 1897 was a milestone in the acceptance of Impressionism in America. The artists who formed this group had become increasingly dissatisfied with the twenty-year-old Society of American Artists; they felt it had become too conservative, losing the characteristics that had distinguished it from the National Academy of Design. Made up of prominent American Impressionists from New York and Boston, the Ten were Frank Benson, Joseph DeCamp, Thomas Dewing, Childe Hassam, Willard Metcalf, Robert Reid, Edward Simmons, Edmund Tarbell, John Henry Twachtman, and J. Alden Weir. (William Merritt Chase joined the group in 1906, replacing Twachtman, who had died in 1902.) Countering the Society's crowded displays of works mounted floor to ceiling, the Ten organized small shows in which all paintings were hung "on the line" (at eye level). During their two decades of activity, the Ten represented an academy of Impressionism in America.

Some members of the Ten were more committed to

Impressionism than others, and those who were considered confirmed Impressionists often created works that fell outside Impressionist bounds. Hassam was the most consistent Impressionist among the Ten, producing works that were closest to French examples, yet in the 1900s he painted a number of idealized female subjects that relied for inspiration on Greek art and the murals of the French artist Puvis de Chavannes. Twachtman adopted Monet's spontaneous methods but rarely painted sunlit scenes saturated with color. He preferred gray days and misty snow scenes. Even Weir, a proclaimed Impressionist in the 1890s, created landscapes after the turn of the century, in which a decidedly romantic spirit emerged, and portraits that were conservative, similar to those he had painted in the 1870s. Metcalf joined Impressionist methods with a realistic landscape style that recalled the art of the Hudson River School. Reid united Impressionism with a decorative approach, combining plein-air color and handling with a concern for the graphic placement of forms on canvas.

Chase never actually affiliated himself with Impressionism; instead he appropriated its techniques to bring an expressivity to his well-crafted and veristic art. Dewing borrowed minimally from Impressionism and Tarbell and DeCamp turned away from Impressionism after 1900, adopting styles strongly influenced by the Old Masters. Benson held to a not-unusual pattern of going back and forth between brilliant outdoor Impressionist scenes and dark, quiet interiors. Many other American artists, such as Robert Vonnoh and Dennis Miller Bunker, fell into a similar category of the "vacation Impressionist," painting bright open-air landscapes and figural works during summer holidays and traditional portraits during winters in their studios.

In general, then, Americans took individual approaches to Impressionism. Unlike their French counterparts, they were not breaking from a bureaucratic art establishment, so they were less concerned with creating an extremist or rebellious art, and they did not feel it was contradictory to combine approaches. Many Americans, in fact, adopted Impressionism without completely abandoning the lessons learned in the academies. While they painted landscapes with a freedom and animation inspired by Monet, they did not dissolve objects in light and atmosphere as he did. They rendered human forms with the modeling techniques instilled during life drawing sessions, and they arranged their sitters carefully within well-defined spaces, as they had been taught by instructors who were preparing them to execute large-scale scenes drawn from history and mythology.

Thus, the freedom to experiment and to merge seeming disparities characterizes American Impressionism. For this reason, the style quickly pervaded the country. Impressionism came to be seen as democratic, open to variation and interpretation. Hamlin Garland noted in 1894 that dependence on foreign traditions was likely to be "fatal to fresh, individual art," and he urged artists to develop divergent and unique responses to Impressionism. The style was viewed not as a radical importation but as particularly suited to the expression of the beautiful and enduring aspects of American life.

American Impressionism was of a gentler sort than French. In subject matter, American Impressionists avoided the kinds of urban scenes that had caused controversy in the art of Manet and Degas. Instead they painted luxurious interiors inhabited by contemplative women—quiet refuges from the pressures of modern life. Landscape was the preferred subject for Americans, probably because of the importance landscape had long held in the nation's art. Impressionist paintings of remote, refreshing outdoor scenes continued the tradition, established by the Hudson River School, of revealing the untouched splendor of the New World. Other landscapes show signs of civilization merging harmoniously with the countryside. In their rarer, urban scenes, American painters focused on picturesque squares and parks, avoiding crowded streets and tenement districts.

In 1913, American art was changed irreparably by the Armory Show, held in Chicago and New York. It was in this landmark exhibition that the works of Picasso, Duchamp, Cézanne, and Matisse were initially seen by a broad American audience. The outraged response to their radical new art echoes in many ways the earlier reaction to French Impressionism. After initial scorn and mockery, Americans took up the modernist banner and thrust themselves into an exploration of abstract modes of representation. Weir again shifted allegiances and yielded to yet another wave of change. Elected president, in 1911, of the Association of Painters and Sculptors, which organized the Armory Show, he now represented the establishment, but his support of modernism made him an important link between old and new. Impressionism had become staid and respectable and was being overshadowed by abstract painting and overlooked by critics and scholars.

It has only been recently that a new interest in American Impressionism has arisen. Yet, already, numerous publications have charted the history of the movement in this country, examined the careers of the major artists, and brought to light information on artists working in the Impressionist style even into the 1930s. The essays in this collection rely on studies that have appeared thus far, but, rather than presenting an overview of the movement, this book is intended as a selection of the finest Impressionist examples created by Americans. In some cases, the selections are extremely well known; in others, they are less familiar images of noteworthy beauty and interest. Diversity and balance were sought; the plates demonstrate the range of subjects and styles essayed by American Impressionists, and in the case of some artists, selections reflect the variety, and, in many cases, the different periods, within their careers.

This volume marks the centennial of the birth and spread of Impressionism in America: for us, the sparkling landscapes and tranquil interiors are nostalgic memories of an era of gentility, expressing a longing for a peaceful existence and a pristine landscape that is again strongly felt today.

AMERICAN IMPRESSIONIST
MASTERPIECES

MARY CASSATT
1844–1926

Young Woman in Black, ca. 1880

The art of Mary Cassatt belongs more to the Impressionist movement in France than to that in her homeland. In the mid-1880s, when America's artists and public were first becoming aware of the new French style, Cassatt had already been working as an Impressionist for almost a decade.

Born in Allegheny City (now part of Pittsburgh), Cassatt grew up in Philadelphia, though much of her youth was spent abroad with her wealthy parents. After five years of study at the Pennsylvania Academy of the Fine Arts, she recognized the deficiencies of art training in America and the limited opportunities for women. Escorted by her mother, she went to Paris in 1866, where she continued her instruction, and in 1872, she settled there for good.

Working at first in a dark, conservative style influenced by seventeenth-century Spanish art, Cassatt gradually adopted bold, flat color areas and a light palette, especially after seeing the work of Edgar Degas. She reported to her friend Louisine Havemeyer, in 1915, "How well I remember, nearly forty years ago, seeing for the first time Degas's pastels in the window of a picture dealer on the Boulevard Haussmann. I used to go and flatten my nose against that window and absorb all I could of his art. It changed my life." Independently, Degas had responded with enthusiasm to Cassatt's work on seeing it at the Salon of 1874, and in 1877 he invited her to exhibit with the Impressionists. She first did so in 1879.

In the 1880 Impressionist exhibition, Cassatt displayed a number of images of women, among them *Young Woman in Black* (then titled *Portrait de Mme J.*). Although it depicts not a model, but an individual who belonged to Cassatt's circle, the work does not follow the accepted portrait conventions of the era. Rather than posing the figure against a neutral background that betrayed a studio setting, Cassatt chose to present her subject in an ordinary, real-life situation. Dressed in black with a veil over her face, gloves still firmly on, the woman is probably on a social outing. By cropping the figure and showing only partially the room in which she sits, Cassatt focuses on a view of life in an intimate glimpse.

Frontally placed, the woman almost protrudes from the frame. This bold interrelation between figure and space was a hallmark of the Impressionist style, a way of expressing the transitory nature of modern experience. Cassatt also uses innovative stylistic means to create a unified composition. The dark form of the figure is flattened and defined with broad, graceful brushwork, an approach that owes to Manet's reinterpretations of Spanish masters such as Velázquez. Cassatt's simplified design and repetition of geometric forms also reflect her appreciation for Japanese art.

Like Degas and Manet, Cassatt uses pose to convey modern manners. The subject leans forward, conveying a sense of attentiveness, yet her gaze, showing an assuredness and refined composure, is reflective. She enjoys the new social freedoms that the era allowed women, while maintaining a dignified demeanor appropriate to her sex.

Oil on canvas, 31 1/4 × 25 1/4 in. (79.4 × 64 cm). The Peabody Institute of The City of Baltimore, on indefinite loan to The Baltimore Museum of Art

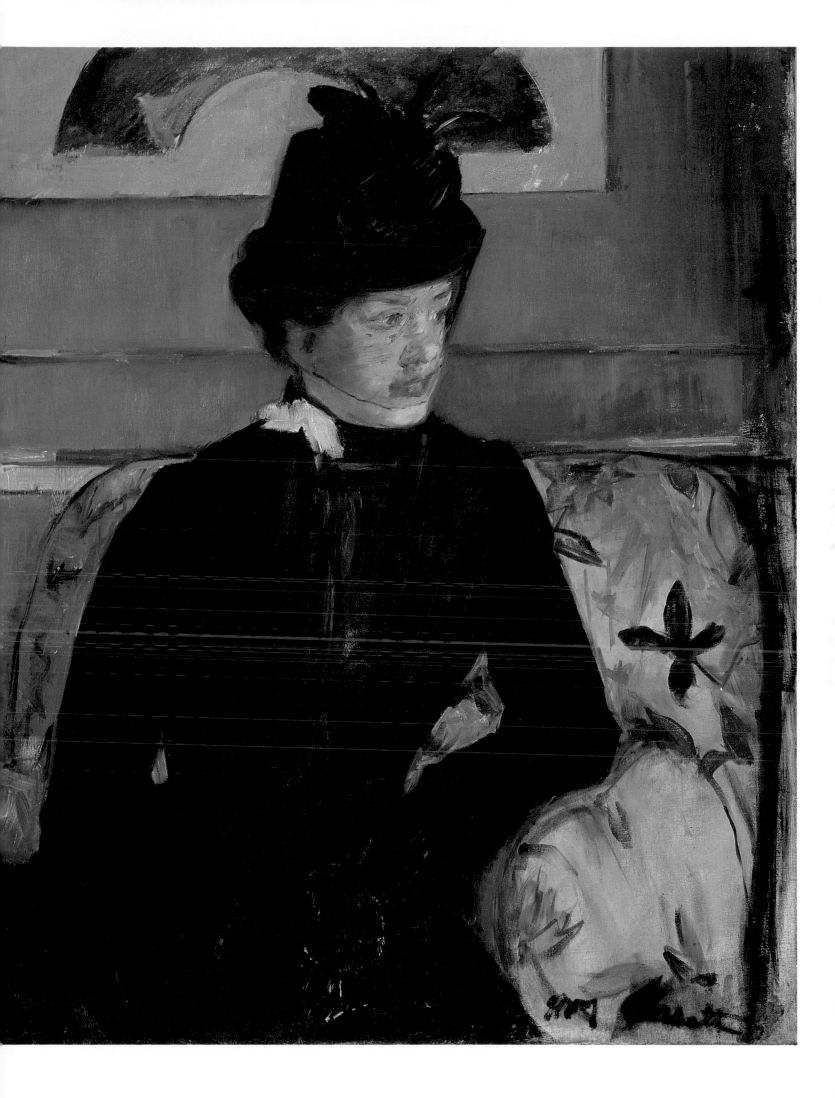

MARY CASSATT
1844–1926

The Banjo Lesson, 1894

The artistic medium of pastel enjoyed a revival among the French Impressionists, as its spontaneity and fresh color effects proved perfectly suited to representations of the dynamism of modern life. Encouraged by her friend and mentor Edgar Degas, who rendered many of his finest images in pastel, Mary Cassatt adopted the medium shortly after settling in Paris. By the 1890s, she had formulated her mature approach to pastel, using its dual capacities as a vehicle for drawing and for achieving painterly effects. *The Banjo Lesson* demonstrates her proficient handling of, as well as her sensitivity to, the inherent properties of the medium.

Cassatt would begin by delineating the contours of her subject, attaining a crisp linear design; having done a version of this composition in a colored print (drypoint and aquatint), she translated into pastel its flowing lines. Uniting the figures in a pyramidal arrangement, Cassatt breaks up the strong verticals and horizontals with the banjo, which cuts diagonally across the design, reflecting her close study of Japanese prints. Aside from the outlines, Cassatt uses pastel throughout the picture in a free manner that approximates her oil-painting technique. Yet her application is far sparer here, as she brings broad areas of bare paper expressively into her design, the color of the paper providing the work's underlying tone. The rhythm of Cassatt's strokes, applied in broken, parallel dashes of color, adds a spirited energy.

The Banjo Lesson belongs to a long tradition of works depicting women playing music. Medieval and Renaissance artists had portrayed angels playing lyres, and Dutch Masters such as Jan Vermeer and Pieter de Hooch had shown women playing lutes and other instruments, often in the presence of suitors. The French Impressionists also depicted female musicians, but these were generally café performers rather than young women in the privacy of their homes. Cassatt's choice of this subject coincided with her turn to the art of the Old Masters for inspiration. She may have considered this work an update of a Vermeer interior, but her painting has modern connotations, as she presents music as an area of female accomplishment, suggesting the new professional status attainable to women in arts fields.

In *The Banjo Lesson*, the older figure exudes a sense of quiet confidence, while her companion pays careful attention to her technique. Thus, Cassatt does not present the banjo as a mere prop. With an expertise apparent in the motion of both her hands, the musician appears to pluck rather than strum the banjo, making it likely that she is playing classical music, for the banjo had recently become a popular parlor instrument. Cassatt's choice of a banjo in both the pastel and a mural (for the 1893 World's Columbian Exposition) suggests that she selected it as a symbol of her national identity. The instrument had originated in the American South, and Cassatt surely knew of the banjo players that appear in the works of the American genre painter William Sidney Mount. The banjo had become popular in the 1890s, as Americans touted their cultural heritage, and Cassatt, despite her long residency in France, apparently wished to maintain a connection to her native land.

Pastel on paper, 28 × 22 1/2 in. (71 × 57 cm). Virginia Museum of Fine Arts, Richmond. Museum Purchase: The Adolph D. and Wilkins C. Williams Fund

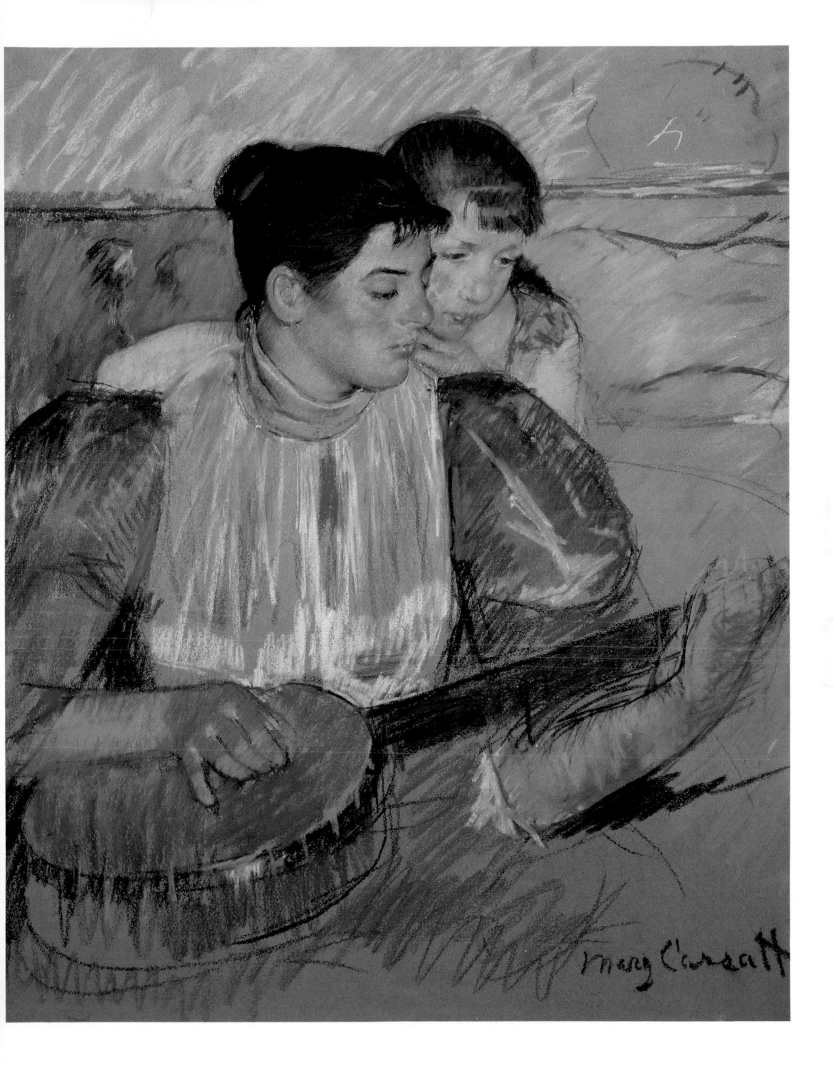

MARY CASSATT
1844–1926

Young Mother Sewing, ca. 1900

During the 1890s, Mary Cassatt turned increasingly from images of women in society and toward an examination of their private lives: their domestic roles and inner experiences. She became devoted to maternal themes especially and rendered them almost exclusively after the turn of the century until the end of her career.

In her paintings of mothers and children, Cassatt drew inspiration from the Madonna and Child imagery of Renaissance and Baroque painting. In *Young Mother Sewing*, for instance, a mother and daughter are linked by their close positioning and by a strong pyramidal composition. Although Cassatt omits any religious connotations, the painting exudes the spirituality of the earlier, symbolic paintings. She presents the universal relationship between her subjects without the theatricality or coyness of Victorian depictions; instead, she expresses it subtly, through gesture, attitude, and physical resemblance.

By raising her left hand slightly, the mother gracefully accommodates the child, who leans on her lap. The mother's arms circle halo-like above the child's head in a subtle modification of the earlier tradition. The child gazes outwardly, but does not focus on the viewer; instead, her expression is one of privacy and introspection that matches her mother's peaceful concentration on her work.

Cassatt's turn-of-the-century works demonstrate her increased interest in coordinating all aspects of a picture's design. Again, Renaissance and Baroque paintings had their influence here, yet her study of Japanese prints was the primary stimulus for this new concern in her art. Cassatt had a deeper understanding of Japanese art than did the many artists who incorporated Oriental motifs into their works in response to the *japonisme* craze that swept Paris in her day. In *Young Mother Sewing*, the linear emphasis, flattening of forms, and compression of space exemplify Cassatt's ability to integrate basic aspects of the Japanese aesthetic into her painting without detracting from its feeling—in this case, of the subjects' quiet experience of each other. Although the mother's chair is set at a slight angle, the strong lines of the window casement accentuate her centrality. The stripes of the mother's dress and the child's bent arm repeat the vertical lines, while the window ledge and the bureau balance the composition by stressing the horizontal. A generalized landscape is a compositional element, fixed by the grid of the window, which divides it into sections and emphasizes its flatness, and a high horizon line serves to tilt surfaces upward, de-emphasizing depth. Elements within the room further contract the space. The mother's chair is in front of the bureau, but seems to be on the same plane. The flowers, which echo the rounded shape of the mother's hairstyle, draw one's eye toward the figures and away from the window.

In her depictions of women absorbed in reading or sewing, or engaged with children, Cassatt often conveyed their quiet strength and ability to find satisfaction in themselves. Often seen primarily as images of domestic felicity, works such as *Young Mother Sewing* may also be considered as giving recognition to the confidence and resourcefulness that Cassatt perceived in the women of her era.

Oil on canvas, 36³/₄ × 29 in. (93 × 73.6 cm). The Metropolitan Museum of Art; Bequest of Mrs. H. O. Havemeyer, 1929. The H. O. Havemeyer Collection

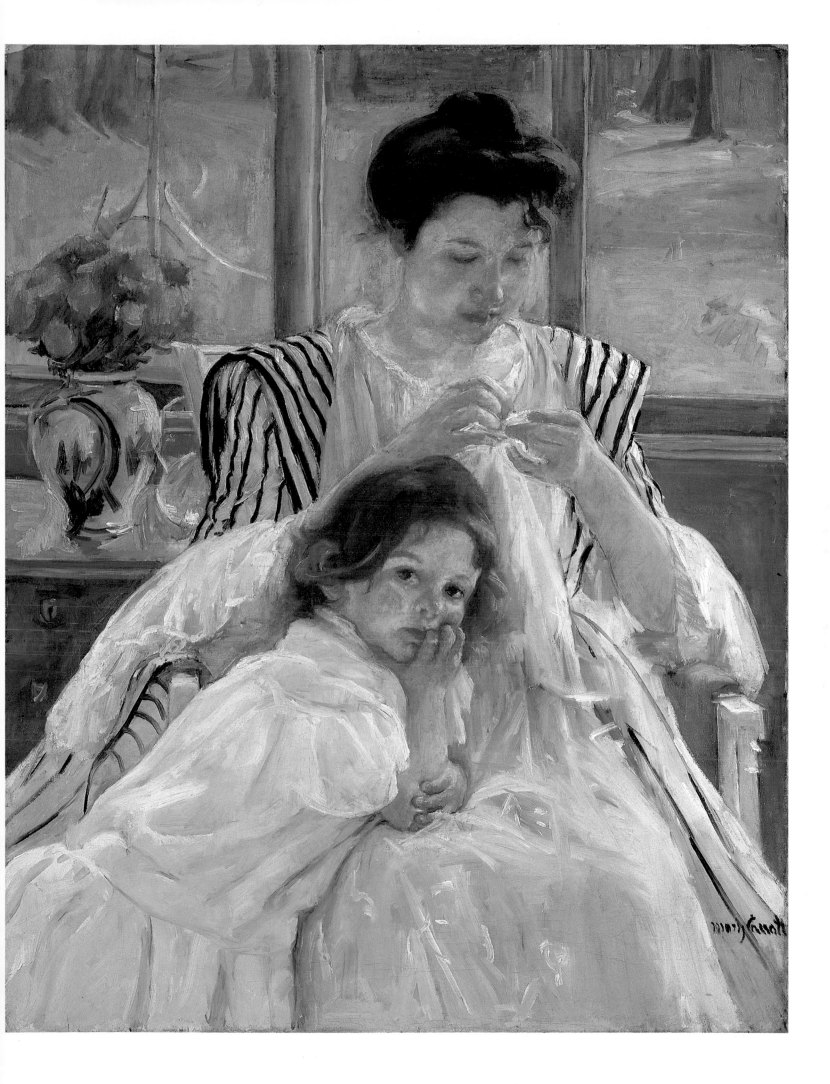

JOHN SINGER SARGENT
1856–1925

Carnation, Lily, Lily, Rose, 1885–86

Born in Florence to American parents, John Singer Sargent was an expatriate throughout his life. During the 1870s, he studied in Paris with the unorthodox, anti-academic painter Emile-Auguste Carolus-Duran, whose *alla prima* method—one of painting a scene all at once, and without later retouching—Sargent would master. In Paris, Sargent first gained a reputation for his portraits of the leisure class, in which he conveyed character through dramatic brushwork and nuances of gesture and expression. Indeed, these abilities are apparent in his famous *Madame X* (in the Metropolitan Museum of Art, New York), which scandalized audiences at the Paris Salon of 1884 by revealing the haughty pretension of a glamorous young American who had recently married a wealthy Parisian. His reputation damaged by the negative response, Sargent moved to London, which was his home for the rest of his career.

Sargent's first paintings of figures in the outdoors, created during the 1870s, were rendered in the studio and, with their emphasis upon tonal effects, owed more to Whistler than to Monet. In 1884, while visiting the Vickers family, in Sussex, England, he painted a large garden scene in which he advanced toward the adoption of a plein-air style.

For his next effort, in late August of the following year, Sargent joined the American painter Frank Millet in the Cotswold village of Broadway. This time, working in Millet's garden, he filled the canvas with ivory-colored lilies and pink carnations. Rendered at dusk, the scene is illuminated by gleaming peach and orange lanterns. Sargent notes the effect of their light, demonstrating a concern for specificity not evident in his earlier outdoor scenes. At first, Sargent used Millet's dark-haired five-year-old daughter as his

model. Exercising his new interest in natural illumination, Sargent chose to portray her in a blond wig that would look more luminous in the glow of her lantern.

Sargent continued painting *Carnation, Lily, Lily, Rose* on his return to Broadway in the autumn of 1886, when he worked in a different garden with different children, the seven- and eleven-year-old blond daughters of another sojourning artist. For two months, Sargent painted daily in the open air. As the American painter Edwin Blashfield reported,

each evening at twenty-five minutes to seven Sargent would drop his tennis racquet and going into the seventy-foot long studio, would lug out the big canvas as if he were going to fly a huge kite. We would all leave our tennis for a time and watch the proceeding. Little Pollie and Dollie Barnard, daughters of the well-known English illustrator . . . would begin to light the Japanese lanterns among the tall stemmed lilies. For just twenty-five minutes, while the effect lasted, Sargent would paint away like mad, then would carry the canvas in, stand it against the studio wall and we would admire.

With *Carnation, Lily, Lily, Rose*, Sargent demonstrates a fully Impressionist technique of glimmering color and immediacy, but with strongly articulated forms and, curiously, the sentimental proclivities of English Victorian paintings. The identically-dressed children with softly glowing features symbolize an ideal childhood. The work's title, borrowed from a popular song, adds to its lyrical quality.

Oil on canvas, 68½ × 60½ in. (173.9 × 153.6 cm). The Tate Gallery, London

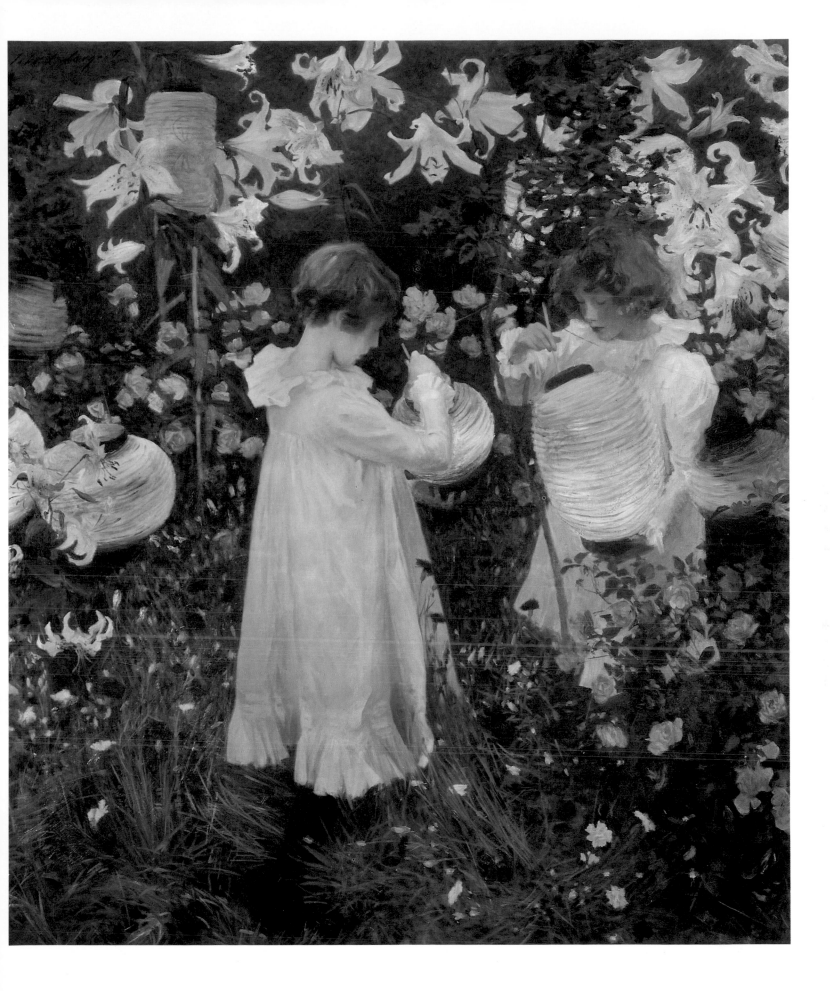

JOHN SINGER SARGENT
1856–1925

Paul Helleu Sketching with His Wife, 1889

Executed during the summer of 1889, *Paul Helleu Sketching with His Wife* reveals the development of John Singer Sargent's Impressionist aesthetic from his more cautious images of the middle of the decade. One of the artist's best-known works, the canvas shows the fluid, chromatic style that he had evolved gradually during summers spent in the English countryside from 1887 to 1889, and the confidence and boldness with which he now approached outdoor work.

The painting presents Paul Helleu, a society portraitist like Sargent, stopping on a canoe trip with his wife to paint in the outdoors. Sargent had rendered other images of artists working in the open air, notably Claude Monet and Dennis Miller Bunker; of these, *Paul Helleu* most clearly combines portraiture and landscape. In his painting of Monet (in the Tate Gallery, London), the artist and his canvas are integrated within the broader landscape scheme, and the canvas, itself depicting a landscape, serves to focus the viewer's attention on the forested surroundings; in *Paul Helleu*, the artist is the picture's focus. The overhead angle forces the viewer's attention on Helleu's right hand, which gracefully and confidently manipulates his brush on a canvas that is propped against a patch of high grass. Depicting Helleu's left hand holding a number of additional brushes, Sargent pays homage to the outdoor painter's art and suggests the necessity of being ready with fresh colors to capture sudden shifts of color and light in the landscape. Helleu's interest in his work is expressed through the taut angle of his arm and of his swivelled head. His face is partially covered by his broad-brimmed straw hat, yet the intensity of his concentration is apparent.

Even the landscape seems to cooperate with the attitude that the artist shows—in fact, this is probably Sargent's most carefully structured Impressionist work. The canoe's assertive, jutting angle adds dynamism to the composition and repeats the line of Helleu's upper left arm. The canvas edge corresponds to his bent knees. Only the painter's wife, ignored by her husband and gazing listlessly into space, breaks from the controlled tension of the work. Obviously not an artist, Helleu's wife doesn't appear to have a sympathetic understanding of the artistic personality. (By the early twentieth century, women artists had become a more common phenomenon; many of Sargent's images of women artists from later in his career show them taking more active roles than their male companions.)

The theme of *Paul Helleu* is the inspired passion of the artist compelled by his vision. Sargent, who was known for "suddenly planting himself down nowhere in particular, behind a barn, opposite a wall, in the middle of a field," to the astonishment of artists who always carefully selected their views (as the artist's biographer Evan Charteris noted), assuredly saw himself reflected in Helleu. This sense of association with a fellow painter who also specialized in portraits of upper-class figures, but who had caught the passion for outdoor work, contributed both to the brilliant subtlety of Sargent's characterizations of Helleu and his wife and to the strength of his expressive means.

Oil on canvas, 26⅛ × 32⅛ in. (66.3 × 81.5 cm). The Brooklyn Museum; Museum Collection Fund

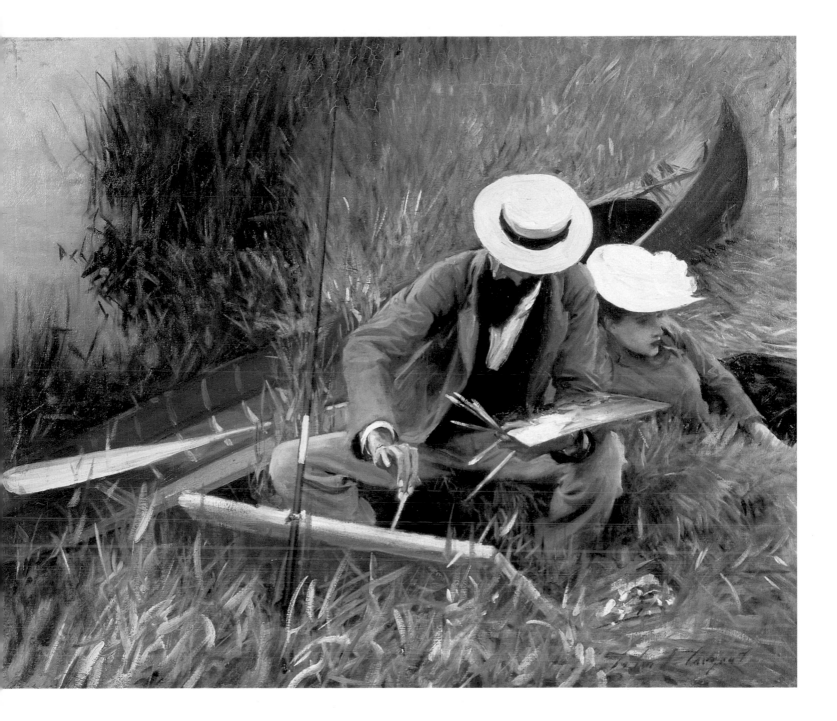

ROBERT VONNOH
1858–1933

In Flanders Field, 1890

Robert Vonnoh worked in two entirely different styles throughout his career. On the one hand, he created precise and realistic portraits that reflected his training at traditional art schools in Boston and Paris. On the other hand, he rendered landscapes by applying bright pigments directly from the tube in broad masses, a technique that was extremely advanced for his day. With *In Flanders Field*, he unites these two styles, creating a vibrantly painted work that expresses the genteel pleasures of the outdoors.

Vonnoh developed an Impressionist style in the late 1880s, during a number of sojourns in the French town of Grez-sur-Loing. Located south of Paris and near Barbizon, where French artists at mid-century had first begun to paint en plein air, Grez enjoyed widespread popularity in the late 1870s and 1880s, when scores of American, British, and Scandinavian painters worked in the town and its environs. The locale offered many opportunities for a landscape painter. Vonnoh was among the very few artists in Grez who attempted to capture novel effects of light and color in the outdoors, for the predominant landscape style in Grez was conservative. He had perhaps seen Monet's paintings of poppy fields by the end of the 1880s, but he seems to have formulated his Impressionist style essentially on his own and used it several years earlier than most of his American colleagues.

Executed in Grez, this work is Vonnoh's best-known painting, and one that he intended as a major exhibition piece. In creating it, he executed numerous studies over a two-year period, depicting sections of poppy fields (the picture is also known as *Coquelicots*, or *Poppies*).

Vonnoh was successful in his aim; *In Flanders Field* was shown at the Paris Salon of 1891, and it was singled out by a critic as "the crown of the collection" when it was included in Vonnoh's solo exhibition at the Durand-Ruel Galleries in New York in 1896. There were a number of reasons for the painting's popularity. Although Vonnoh rendered the poppies in the modern style, he relied on his academic background for his depiction of the woman in the foreground, modeling her with traditional methods. Whereas the fields were a place for backbreaking labor to the Barbizon School, in this work they offer nothing but pleasure.

Like Reid and other American Impressionists, Vonnoh links women and children with the beauty and delicacy of flowers. The woman, bending gracefully to add a blossom to her bouquet, is herself flowerlike, wearing a patterned blouse that Vonnoh stipples with color. Her hat, adorned with a wide feather, has a bloomlike quality. The sense of jubilation is furthered by a young boy who triumphantly holds a bunch of flowers aloft. The composition contributes to the sense of harmony and ease that the work expresses. The flowers, which at first appear to spread in all directions, are actually arranged in strips that line up with the horizon. The farmhouse at the crest of the hill provides an inviting presence, its long, low structure continuing the lines of the gently weaving rows of flowers. Calculated to please, Vonnoh's canvas still has the power to immerse the viewer in the beauty of a meadow aglow with flowers.

Oil on canvas, 58 × 104 in. (147 × 264 cm). The Butler Institute of American Art, Youngstown, Ohio

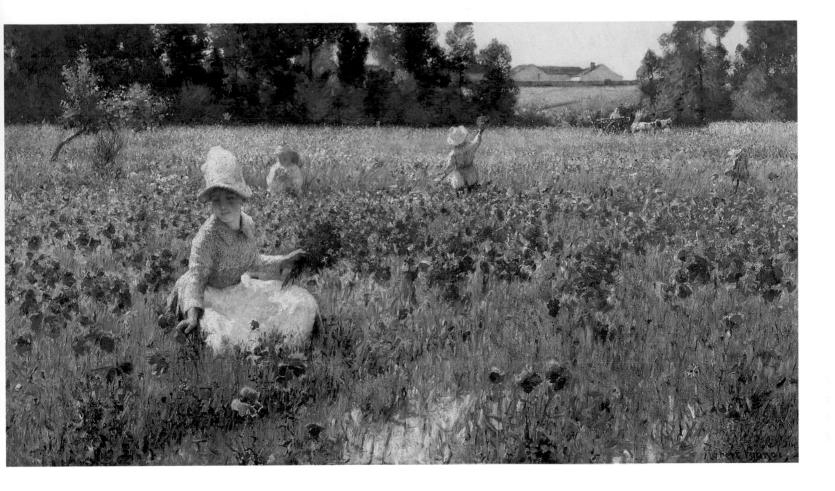

DENNIS MILLER BUNKER
1861–1890

The Pool, Medfield, 1889

M y room is filling up with canvases, and the country seems more tender and beautiful every day," Dennis Miller Bunker wrote to a friend in a letter, sent from Medfield, Massachusetts, in late July of 1889. *The Pool, Medfield*, is a view of a quiet, intimate landscape. Rendered with animated brushwork and a sparkling palette of various greens highlighted with yellows, pinks, light blues, and peach tones, it was a result of the productive and gratifying summer Bunker spent in a small New England town located fifteen miles south of Boston.

Influenced by the French Barbizon painters, Bunker had employed a dark, tonal manner during the mid-1880s, a time when he was studying in Paris and painting in Brittany. By the end of the decade, he had adopted an Impressionist style, a development in his art prompted by his contact with the important American expatriate painter John Singer Sargent. Bunker had been introduced to Sargent in the winter of 1887 by the arts patron Isabella Stewart Gardner when Sargent was executing portrait commissions in Boston. On Sargent's invitation, Bunker joined him during the summer of 1888 in the English village of Calcot. Painting there in an experimental mode inspired by a recent meeting with Claude Monet, Sargent was creating some of his most adventurous outdoor canvases, filled with bold color and active brushwork, but as a recent student of Jean-Léon Gérôme, the French academic painter of classicized figural subjects, Bunker had reason to feel reluctant to follow Sargent's lead. Although the two artists worked side by side, Bunker was apparently unable to feel at ease with plein-air work.

By the next summer, however, Bunker had overcome his reluctance. In *The Pool, Medfield*, he captures fleeting effects, using quill-like strokes (similar to those used by Sargent in *Paul Helleu Sketching with His Wife*) and a scintillating color scheme to convey light flickering across the surface of a windswept meadow. An elevated horizon line makes the canvas seem tipped upward, concentrating attention on its surface design. The painting appears equally as an abstract pattern of jewel-like dots of color and a representation of a contemplative and refreshing landscape bisected by an effervescent brook.

Bunker's charm and good looks made him an extremely popular art teacher in Boston. Yet, throughout his career, he preferred to work in isolation, away from other artists and crowded urban centers. Medfield provided exactly the solace that spurred his creativity. Bunker wrote to Gardner in July of 1889 of the brook running through "most lovely great meadows—very properly framed in pine forests and low familiar looking hills—all very much the reverse of striking or marvellous, but very quietly winning and all wearing so well, that I wonder what more one needs in any country. The calmness of everything here—its roughness and simplicity is to me most charming and restful—and I feel more happy and in better courage than in the hurry and countless duties of winter life." Bunker felt a sense of peace during the summer of 1889 that he would not experience again. He returned to Medfield the following summer, but this time he was dissatisfied with his art and was in a mood of despair. At the end of the following year, a sudden, fatal attack of influenza cut short his promising career.

Oil on canvas, 18³/₈ × 24¹/₄ in. (45.7 × 61 cm). The Emily L. Ainsley Fund; Museum of Fine Arts, Boston

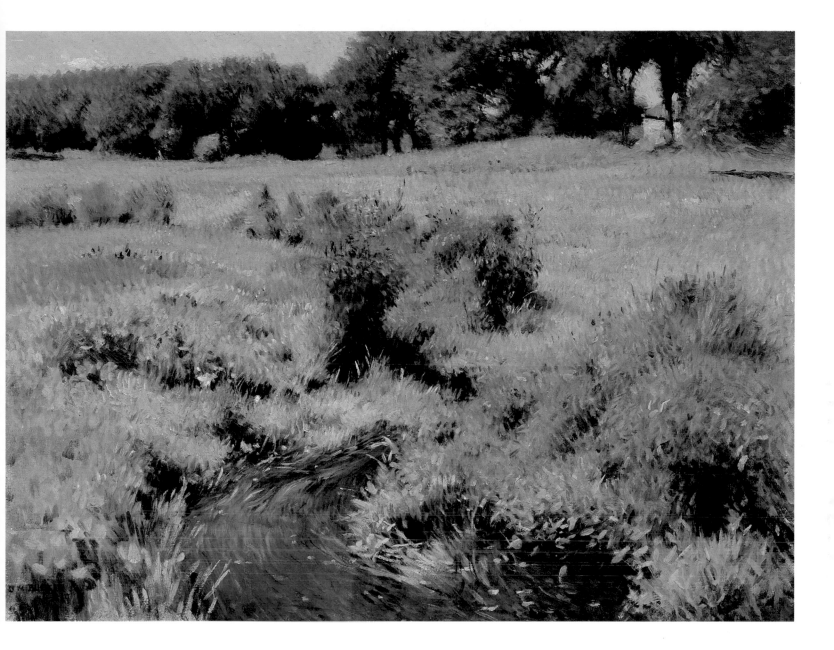

JOHN LESLIE BRECK
1860–1899

Garden at Giverny, ca. 1887

ohn Leslie Breck, Willard Metcalf, Theodore Robinson, and a few other American artists discovered the Normandy village of Giverny by chance in 1887; it was only afterward that they learned that Monet had been living there since 1883.

Of the original American Givernois, Breck seems to have been the most open to Monet's experimentation. Although Robinson became close to Monet, he never abandoned the methodical technique born of years of training in Paris. Metcalf shifted to a lighter palette while in Giverny, but he maintained the interest in a Tonalist style that had dominated his art during the previous decade. In contrast, Breck, despite an equally extensive academic background—he had studied in Munich, Antwerp, and Paris—readily let go of formal rules and adopted the brilliant contrasts of color and vital brushwork characteristic of Monet. Although this brushwork owes something to his Munich years, 1878 to 1882, he replaced the dark, monochromatic palette of his Munich canvases with the rich color range that Monet used to dazzling effect.

Breck probably became acquainted with the French master shortly after arriving in Giverny. By 1887, Monet had come to trust and like the younger painter. Granting him a rare privilege, he allowed him to paint in his garden. *Garden at Giverny* is almost certainly one of the views that Breck painted on Monet's well-guarded property, and it may be one of the paintings that writer Hamlin Garland saw, around 1889, at the Boston home of the artist Lilla Cabot Perry. Breck's vivid canvases, Garland wrote, "so widened the influence of the new school. . . . I recall seeing the paintings set on the floor and propped against the wall, each with its flare of primitive colors—reds, blues, and yellows, presenting

'Impressionism,' the latest word from Paris." *Garden at Giverny* certainly would have shocked Boston, a city still captivated by the tamer French Barbizon school. Dense green vegetation and vibrant flowers fill the canvas; the curving sunlit path plunges the viewer into the garden's exuberant foliage. In contrast with George Hitchcock's paintings of orderly tulip fields, this picture of a path infringed on and eventually subsumed reveals Breck's delight in nature's power, not man's control.

Monet let Breck into his garden, but he was not so amiable when Breck began to court one of his stepdaughters, Blanche Hoschedé. He halted the romance, and Breck left France in disappointment in the fall of 1891, never to marry. After his return to America, he created works that equal the quality of his Giverny productions, but with a new concern with draftsmanship and composition that rein in the freedom and control the jubilation he had expressed in Monet's garden.

Oil on canvas, 18 × 22 in. (45.7 × 55.9 cm). Terra Museum of American Art, Chicago

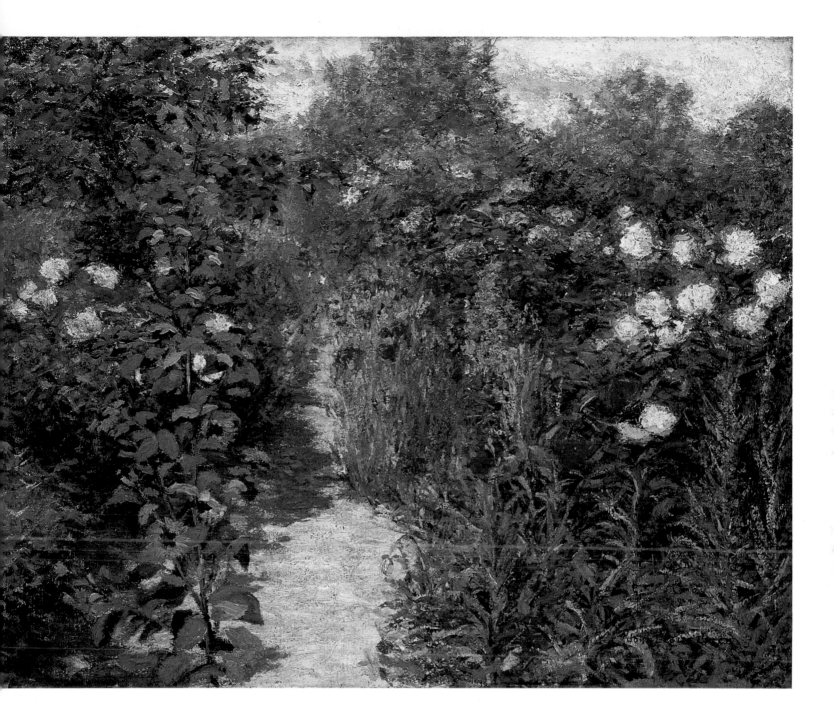

THEODORE ROBINSON
1852–1896

Bird's-Eye View: Giverny, 1889

Theodore Robinson was born in Irasburg, Vermont, and raised in the Midwest. He acquired his formal training in Chicago and New York, but his mature style was formed abroad. Like other artists of his day, Robinson was drawn to Paris. There, in 1876, he studied under the unconventional teacher of John Singer Sargent, Carolus-Duran, who advocated a direct, bravura method of painting. Robinson received further training from a very different instructor, Jean-Léon Gérôme, a painter of historical subjects who stressed accurate draftsmanship, a linear approach to the figure, a study of perspective, and careful research methods. Even after he had become a proponent of Impressionism, Robinson would continue to draw on this more academic schooling, making a synthesis of the approaches of both Carolus-Duran and Gérôme and developing a style that combined expressive fluidity with disciplined control.

Robinson was converted to the radical French style in the late 1880s. In the summer of 1887, along with a group of fellow-artists, he first visited the Normandy village of Giverny, where he met Claude Monet a year later. (Despite his renown as a leading avant-garde artist for over a decade, Monet had been living a quiet, inconspicuous existence there since 1883.) Over the course of the next five summers, Robinson became a close friend of Monet, who generally kept his distance from the throng of young artists in Giverny, and the two discussed painting and viewed each other's latest canvases.

A quiet hamlet, not yet on the tourist route, Giverny did not seem picturesque. The locale's subtle allure, according to Will Low, a friend of Robinson who stayed there during the late 1890s, lay "in the atmospheric conditions over the lowlands, where the moisture from the rivers, imprisoned through the night by the valleys bordering the hills, dissolve before the sun and bathe the landscape in an iridescent flood of vaporous hues. . . ." Like Monet, Robinson captured Giverny's appeal, its simple houses and rolling hills bounded by rows of poplars, and everything softened by gentle mists. Accordingly, in *Bird's-Eye View: Giverny*, the landscape is seen in a diffused light, and its glowing pinks and greens overlap and intermingle throughout. Unlike the French Impressionists, who often use an aerial perspective to survey the forms that disperse chaotically across a landscape, Robinson does it to reveal a design: roof lines fall into a diagonal pattern, while the countryside divides into tiers that gradually align with the horizon. The town's structures are wedged neatly between the planes of the landscape, enhancing the picture over-all as a two-dimensional design.

Both Robinson and Monet painted to achieve immediate impressions of places in and around Giverny, and Robinson adopted Monet's spontaneous brushwork. But while Monet used vivid colors to show how shimmering light merges forms with atmosphere, Robinson preferred a delicate, muted palette, creating soft color arrangements and emphasizing the order he perceived in nature.

Oil on canvas, 25 3/4 × 32 in. (66.4 × 81.3 cm). The Metropolitan Museum of Art, New York; Gift of George A. Hearn, 1910

THEODORE ROBINSON
1852–1896

The Layette, 1892

An intimate scene of a woman sewing in a garden, *The Layette* is of one of a series of four such pictures that Robinson painted during his last summer in Giverny. The painting demonstrates the development, during his years in France, of Robinson's spontaneous yet controlled brushwork and his growing interest in rendering the human figure outdoors. In *The Layette*, Robinson's lithe, freely applied strokes, which convey the fluttering of foliage and soft atmospheric effects, reflect the influence of Claude Monet, Robinson's mentor and friend during his years in Giverny. At the same time, his taut, accurate depiction of the woman derives from his academic background.

In Paris during the early 1880s, Robinson had studied under Jean-Léon Gérôme, a painter of elaborate tableaux featuring classicized figures; Gérôme taught him to integrate his sitters into a space and to point up aspects of pose and attitude. In *The Layette*, the woman's form is strengthened by the tree that arches above her and the wall behind her, which create the stage-set type arrangement for which Gérôme was well known.

To create *The Layette* and the other works in the series, Robinson painted from a live model, recording the outdoor sunlight and shadow effects on the figure, but he also worked from photographic studies of the subject, carefully determining aspects of her position in relation to the landscape and contrasts of light and dark (note the bottom half of the chair). Gérôme, too, had used photographs as *aides-mémoires* in the construction of large narrative compositions on high-minded themes. Robinson, however, had no interest in making morality tales of his paintings; instead, he used the camera to help him capture transitory natural effects. He wrote to his parents, "Painting direct from nature is difficult, as things do not remain the same, [and] the camera helps to retain the picture in your mind." In *The Layette*, the crisp line of the woman's profile, the definition of the folds in her skirt, and the strength of her form against the background demonstrate Robinson's adept use of photographs.

Frequently portrayed by seventeenth-century Dutch painters, the seamstress had become a popular subject for American artists by the 1890s. Painters such as Edmund Tarbell and Joseph DeCamp looked to art-historical prototypes for their compositions which were essentially dark-toned paintings of figures in interiors. For Robinson, the subject essentially provided an opportunity to capture the vibrancy of the landscape with his animated brushwork; at the same time, it allowed him the chance to render a pensive, preoccupied figure with the exactness that his academic training had instilled. The result is a beautifully crafted work of strength and sureness as well as delicacy and grace.

Oil on canvas, 23 × 15 in. (58.4 × 38.1 cm). Spanierman Gallery, New York

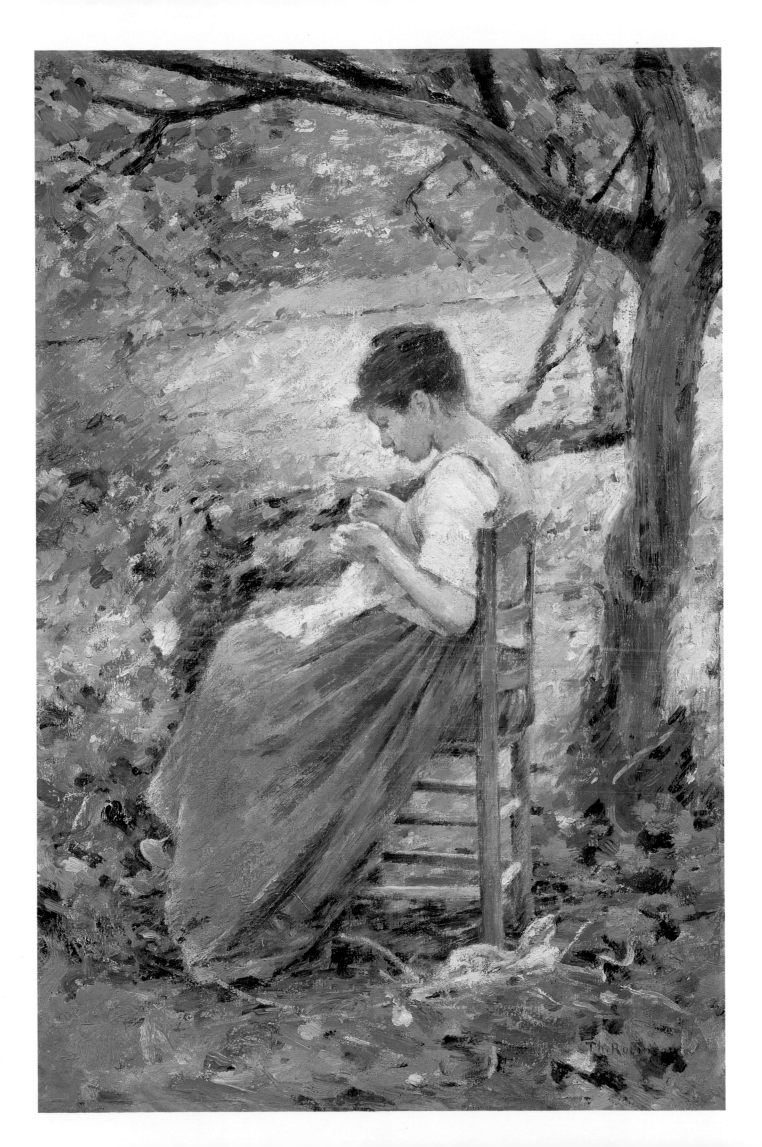

THEODORE ROBINSON
1852–1896

World's Columbian Exposition, 1894

Organized for the four-hundredth anniversary of Columbus's discovery of America, the World's Columbian Exposition, held in Chicago from May to November of 1893, was the major social and cultural event of the era. There had been international fairs in Paris and London in recent decades, and a Centennial Exposition had been staged in Philadelphia in 1876, (the first event of its sort in America), but the Chicago fair was of unprecedented proportions: A marsh south of downtown Chicago was dredged, lagoons were carved out, and monumental buildings were erected. Led by Daniel Burnham, a team of architects designed the buildings in a uniformly classical style and kept the cornices at a consistent height, but the over-all effect was a baroque dynamism that told of an expansive America. "Architectural harmony on a vast scale" was how an 1892 article described Burnham's plans: the White City (as it came to be called) promised a new era in which artists, architects, and urban planners would benefit society together.

For all that it expressed the nation's claim on enduring values of antiquity, the White City was constructed from impermanent materials and was torn down at the event's conclusion. Perhaps because of its short life, Burnham, along with Frank Millet, an artist who directed all the decorative aspects of the fair, proposed the publication of a deluxe history of the Exposition, for which they engaged prominent artists, including Theodore Robinson and John Henry Twachtman, to create illustrations. Robinson had only briefly visited the exposition (probably to oversee the installation of three of his paintings, in the fine-arts exhibition), so to execute Millet's assignment he worked from photographs.

From the beginning Robinson considered the project tedious, noting in his diary that work on his first painting of the fair (now in the collection of the Chicago Historical Society) was "a fearful grind." When Millet asked him to execute a second canvas, he did accept, but he was even more dissatisfied doing that one. After a few days, his spirits were at a low ebb, and he noted: "a lovely day—staid [sic] in my stinking studio and worked on my horrible 'World's Fair.'" Ironically, the result, his *World's Columbian Exposition*, is one of his most appealing works. Closely following his photographic source, Robinson crisply delineated architectural forms and meticulously detailed the scene to create an elaborate record of the event. Still, he invested it with a feeling of firsthand observation. Trees, flecked with confident strokes, seem to rustle gently; water glimmers invitingly; clouds, his own addition, float across a clear sky. Accents of color animate the scene; red touches, especially, draw the eye from the arcaded Fisheries Building at the left, to the flags atop the United States Government Building with its vaulted dome, and across the arching iron bridge at the center.

In a few instances, Robinson deviated from the photographic image. Slightly amending the sky and ground, he created a nearly square canvas, conveying an order that is absent from the more panoramic photograph. Robinson had spent much of his time in France in the preceding years, yet he seems to express pride in his native country, making of the White City a vision of American cohesion and progress.

Oil on canvas, 25 × 30 in. (63.5 × 76.2 cm). The Manoogian Collection

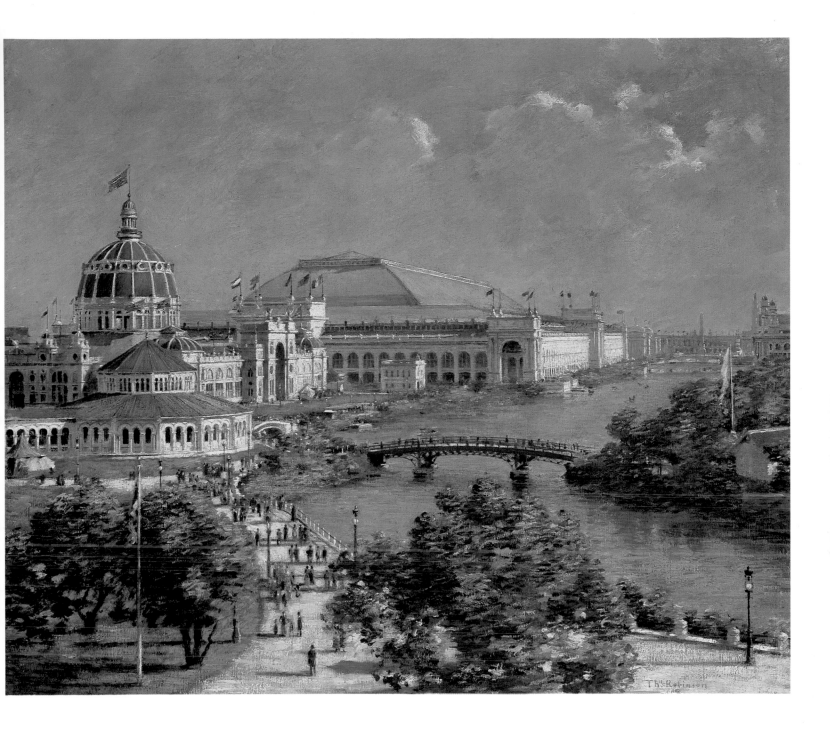

LILLA CABOT PERRY
1848–1933

Giverny Landscape, ca. 1898

Lilla Cabot Perry began her art career late in life. It was not until 1889, when she was forty-one, that her work was first recognized and exhibited. By the mid-1890s she had become acquainted with the major artists of her day, including Claude Monet, Camille Pissarro, and Puvis de Chavannes. Like Mary Cassatt, Perry came from a privileged background that allowed her to spend much of her career abroad and contributed to her ease in European art circles. She had been raised in Boston's elite social and intellectual circles, a descendant of both the Lowells and the Cabots. In 1874, she married a professor of German and English literature at Harvard, Thomas Sergeant Perry, who came from at least as prestigious a New England family; his granduncle was Commodore Matthew Perry, who had opened Japan to the West in 1853.

Perry began her artistic training in Boston, under Dennis Miller Bunker and Robert Vonnoh. Literary as well as artistic interests led the Perrys to Paris in 1886, and for the next twenty-four years they spent about half their time in Europe. A turning point in Perry's career was her visit to the Monet and Rodin exhibition held at the Georges Petit Gallery in Paris in 1889. The same year, Perry purchased a painting by Monet for an American collector and, supplied with a letter of introduction from a fellow artist, sought him out in Giverny. Renting a house near Monet's, the Perrys resided in Giverny almost every summer from 1889 until 1910. While many American artists congregated in the small Normandy town during the 1890s, Perry was one of the few to develop a close, lasting friendship with Monet, and the account she wrote in 1927 for the *American Magazine of Art* is one of the best contemporary articles about him.

Of the Americans in Giverny, Perry was the closest stylistically to the master. As she wrote, Monet had instructed her "to paint what you really see, not what you think you ought to see," and to capture the "object enveloped in sunlight and atmosphere." Perry's *Giverny Landscape* demonstrates that she followed this advice. The scene, probably a view of the narrow River Epte, which wound through Monet's property, is rendered with direct dabs of color. The quick, staccato brushwork, and the composition also, echo those of Monet's own paintings of his Giverny garden. Loosely rendering meadow grasses and the fluttering leaves of pollarded willows, Perry creates a unified, active surface.

Perry did develop an approach to Impressionism that distinguishes her work from that of her mentor: she modified her technique for different elements of a scene. In *Giverny Landscape*, she expresses ephemeral qualities in nature with free, spontaneous dabs of paint; at the same time, she uses smoother brushwork to give strength and volume to certain motifs that are significant to the compositional structure. The pavilion at the left defines the foreground, while tree trunks, painted with long, even brushstrokes, diminish in scale as they recede into the distance. Perry invests the work with an immediate sensuous appeal, a feeling of the vitality of nature enlivened by light and atmosphere. The scene never becomes completely abstract, as do Monet's paintings of the same garden from about the same time. The pavilion gives us a vantage point from which to enter into the landscape's beauty, and the receding lines of trees and the curve of the river draw us gently into the distance.

Oil on canvas, 26 × 32 in. (66 × 81.3 cm). Private Collection

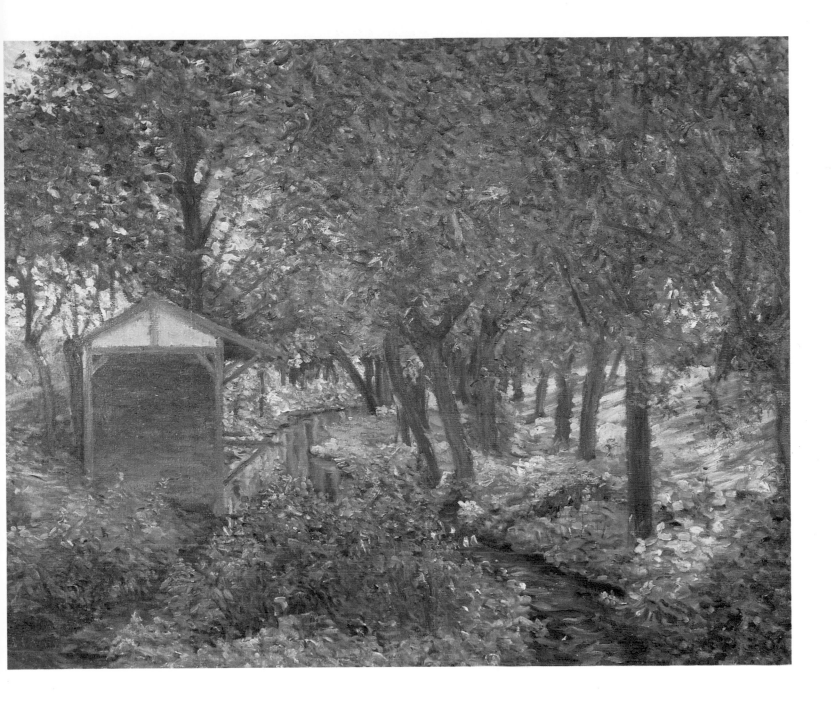

WILLARD LEROY METCALF
1858–1925

Gloucester Harbor, 1895

Born in Lowell, Massachusetts, Willard Metcalf began his career as a wood engraver and figure painter in Boston. Commissioned by *Century Magazine* to illustrate a series of articles about the Zuni Indians by the ethnologist Frank Hamilton Cushing, Metcalf traveled to the Southwest in the early 1880s. What was planned as a brief visit turned into a stay of four and a half years, during which he created some of the earliest accurate images of Indian customs. This commission funded a long-desired trip to Europe, and the artist passed the next several years abroad. He studied at the Académie Julian, in Paris, and spent summers in artists' colonies in the French countryside, where he painted peasant scenes and landscapes influenced by the plein-air painter Jules Bastien-LePage. Metcalf visited Giverny, the home of Claude Monet, in 1887, and perhaps also as early as 1885. However, unlike his friend Theodore Robinson, among others, he did not keep returning to Giverny, and, unlike John Leslie Breck and Lilla Cabot Perry, he did not readily accede to Monet's style. In fact, he was always interested, even when he used an Impressionist palette and brushwork, with gradations of tone in the use of color and with careful draftsmanship—concerns that Impressionism had largely abandoned.

Gloucester Harbor was the first American landscape Metcalf painted after his return from Europe, in 1888. It was an apt choice for an artist who would become an important landscapist, for he was joining a tradition dating back to the mid-nineteenth century, when Fitz Hugh Lane, John Frederick Kensett, Thomas Moran, Winslow Homer, and William Morris Hunt had done important paintings of the region. But unlike his predecessors' depictions of quiet, even desolate, Gloucester sites, Metcalf's scene is busy and civilized by sailboats, houses, and piers. Metcalf set a precedent, in fact, and John Henry Twachtman, Childe Hassam, Frank Duveneck, and John Sloan executed similar scenes from the same viewpoint, East Gloucester's Banner Hill.

Metcalf uses a free, Impressionist technique in the foreground; light-struck grasses are suggested by overlaid dabs of gold and peach pigment. His choice of a high vantage point—a favorite of Monet—may have been inspired by Robinson, whose *Bird's-Eye View: Giverny* (to give just one example) yields a calculated arrangement of fields and rooftops; however, Metcalf employs the high angle for mainly picturesque reasons.

Seen across an expanse of water, the town is a shimmering vision; but it does not dissolve under dazzling sunlight in the stippled French manner. Metcalf varies his brushwork, painting the smooth water and the cloud-swept sky broadly, with thinned-out, fluid color, and the grassy foreground and the houses emphatically, with spontaneous strokes. He painted directly, his delight in giving a tactile quality to the image taking precedence over composition and artifice; nonetheless, *Gloucester Harbor*'s almost square format is pleasingly accentuated by a design in which intersecting diagonals are created by the alignment of sailboats and slanting piers.

Few of the artists who congregated in Gloucester would create such cheerful and sparkling views of the harbor town. It is for works such as these that Metcalf became known as a truly national painter.

Oil on canvas, 26 × 28³/₄ in. (66 × 71.1 cm). Mead Art Museum, Amherst College, Amherst, Massachusetts; Gift of George D. Pratt

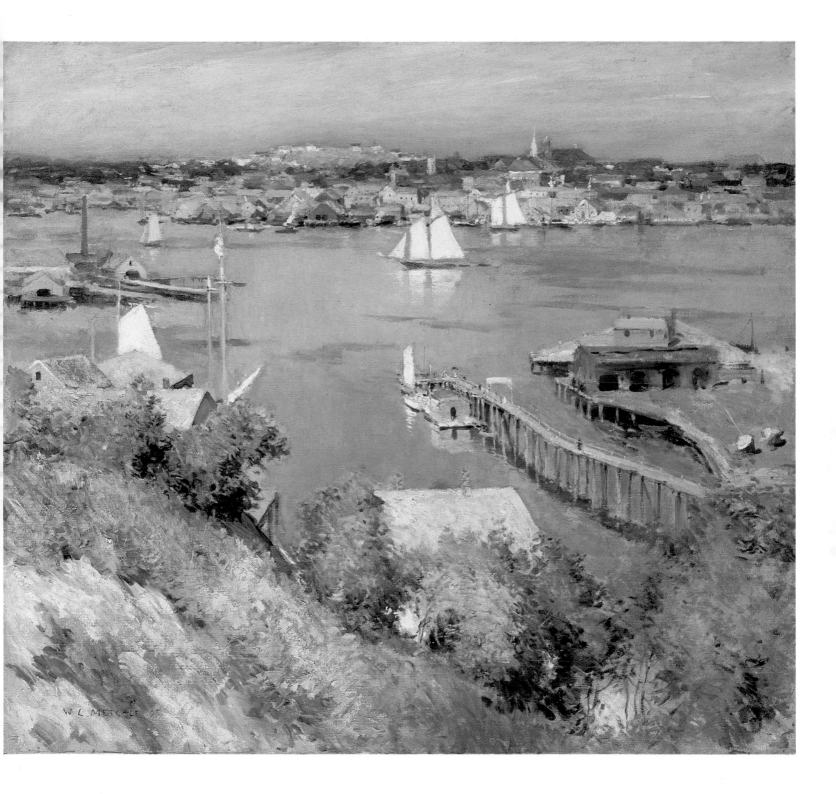

W.L. METCALF '95

WILLARD LEROY METCALF
1858–1925

Thawing Brook, 1911

In 1888, after several years of study and travel in Europe, Willard Metcalf returned to Boston, the scene of his early career, and then moved to New York City, in 1891. He worked as a teacher, illustrator, and portraitist; but by the end of the decade he had turned to landscape painting, and it preoccupied him for the rest of his career. A member of the Ten American Painters, a group that lasted from 1898 until 1919, Metcalf consistently submitted landscapes to its exhibitions, especially New England wilderness scenes. He painted as far north as Maine, near his parents' home in Clark's Cove, and worked outdoors even in the cold of winter.

Metcalf spent the years 1905 to 1910 in Old Lyme, Connecticut, where, along with Childe Hassam, he encouraged a shift in the styles of local artists from Tonalism to Impressionism. Many of Metcalf's Old Lyme paintings feature a bright palette and vigorous brushwork, but he was still interested in a Tonalist approach (in which soft variations on one, predominant color give a hazy, atmospheric quality to a scene) that had characterized his early work. Indeed, Metcalf would continue to combine elements of both styles to record his direct responses to nature.

Metcalf's painting of Cornish, New Hampshire, exemplify a straightforward naturalism that succeeds in expressing poetic feelings for the pristine landscape. On his initial visit there, in the winter of 1909, he first painted scenes of the snowy hills. Metcalf was attracted by the beauty and quiet of the place, and by the presence of an informal community of artists, including Augustus Saint-Gaudens, Thomas Dewing, Maxfield Parrish, and Kenyon Cox. Instead of clustering in a colony, they chose to live in different villages and isolated sites in the region.

Metcalf returned to Cornish, in the winter of 1911, for his honeymoon, with the artist Henriette McCrea, who was almost thirty years his junior. The two stayed at the home of the architect Charles Platt, the designer of the Freer Gallery, in Washington, D.C. Metcalf was extremely prolific, in spite of the bitter cold (his wife carrying equipment), and he worked at a high level of craftsmanship. In *Thawing Brook* Metcalf skillfully captures subtle effects of light and shadow (the work is also known as *Winter Shadows*); the soft lilac that the trees cast on the fresh snow, for instance, is balanced by the interlocking shape of a sunlit snowfield. Metcalf's Impressionist sensibility is apparent in his attention to the colors within shadows, but his fluid application of the white paint is far different from the impasto used to render snow by John Henry Twachtman, a member of the Ten who adhered more closely to the style of Monet. The composition relies on an intriguing balance that shows the influence of Japanese art: a diagonal line of evergreens, guiding the viewer into the deep space, is countered by a brook that holds the eye in the foreground.

Ultimately known as "the poet laureate of the New England hills," Metcalf conveyed his personal pleasure in nature's grandeur.

Oil on canvas, 26 × 29 in. (66 × 73.6 cm). The Fine Arts Collection of The Hartford Steam Boiler Inspection and Insurance Company, Connecticut

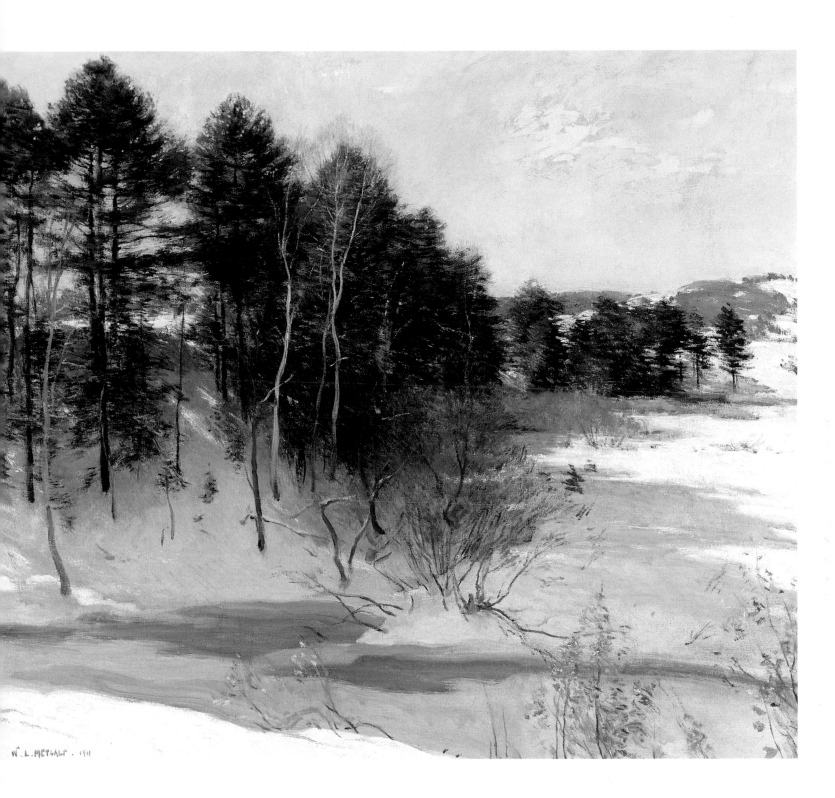

THEODORE WENDEL
1859–1932

Gloucester, Field of Daisies, 1892–96

uring his years abroad, Theodore Wendel was exposed to the artistic revolutions of his day. He studied at the Munich Royal Academy in the late 1870s; from 1879 to 1881, he was one of a group of American artists in Venice, including Duveneck and Whistler, and for a while, he studied at the Académie Julian, in Paris. He gradually became interested in French Impressionism, and in the summer of 1887 he joined John Leslie Breck, Theodore Robinson, and Willard Metcalf in Monet's Giverny.

Wendel probably resided for only one season in Giverny, and in 1888 he returned to America, settling in Boston rather than his native Ohio. He spent many summers on Cape Ann, painting in Gloucester or Ipswich. By 1891, Wendel was avoiding the brilliant palette and aggressive brushwork favored by some of his Boston contemporaries, such as Breck. The *Boston Gazette Telegraph* reported that Wendel returned from France with a "lurid standard" of "crazy-quilt" Impressionism. "We feared that he had lost his grip," the article said, "but the fear was unjustified. He has survived the baptism of light, and having sucked all the available sweetness out of the new school, has gone on to conquer yet newer worlds in his own way. He has discarded the amateur manner of the 'spotters,' but has clung to the clear color, high key purity, and luminosity of the out-door modern landscapist." Other critics praised his originality and the "true and pleasant colors" of his "simple, broad, beautiful" Gloucester works.

These adjectives would certainly describe *Gloucester, Field of Daisies*, a tranquil landscape painted, perhaps, near the edge of the sea—a spot of blue is evident in the left distance. The work demonstrates Wendel's mastery of subtle effects and his avoidance of a formulaic approach to landscape. A profusion of wild grasses, rendered in shades of pale green and beige, spreads out before the viewer, ending in a line of evergreens. By cropping these trees and depicting them almost as a screen across the background, the artist effectively closes in the space and enhances its intimacy. A patch of sky at the left suggests an expanse beyond, but the viewer is enticed to linger in the foreground, as if to meander along the curved meadow path.

Wendel's felicitous choice of this site demonstrates his feeling for the poetry in nature. His handling of the pigment, which ranges from softly layered, sun-dried colors to the flecks that indicate the daisies dotting the landscape and melding at the edge of the grass, reveals his ability to describe a site and, at the same time, to convey his feelings about it. Wendel was "the least mannered, and the most conscientious of any of the so-called impressionists on this side of the ocean," a Boston newspaper declared in 1894, adding that his art "appears to us to have more of nature in it than the majority of the ultra modern landscape painters."

Oil on canvas, 17 1/2 × 29 1/2 in. (44.4 × 74.9 cm). Private Collection

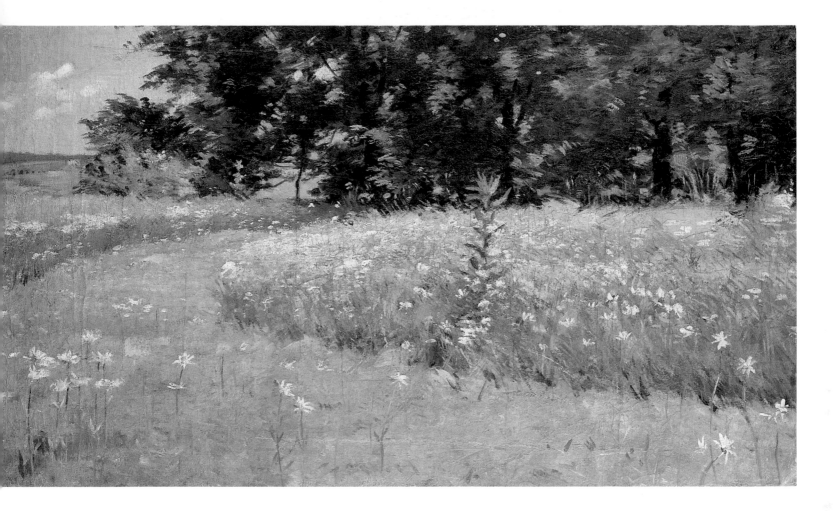

WILLIAM MERRITT CHASE
1849–1916

Back of a Nude, ca. 1885

In 1878, after a period of study in Munich, Indiana-born William Merritt Chase settled in New York, where he participated in all the major exhibitions of the era and was a leading member of prominent art organizations. In the vanguard of the artistic movements of his time, he developed an interest in a "new" medium, pastel, in the years preceding the acceptance of Impressionism in America. Pastel tones had recently been improved upon and new fixatives had been invented to bind their chalklike color to paper and thus maintain their brilliance. The medium offered a spontaneity and freshness of color that paved the way for Impressionism, and Chase found that it suited his confident, direct style. Pastels required no mixing of pigments, no glazes, no drying; a great variety of textures could be attained simply through a combination of drawing, blending, and layering.

Although American artists had seen the pastels that Whistler created in Venice around 1880, they did not consider it a significant medium until Chase and a few colleagues, including Robert Blum and J. Carroll Beckwith, founded the Society of American Painters in Pastel, in 1883. Chase was represented in the four exhibitions this organization held from 1884 to 1890, a period in which his pastel and oil styles matured, each influencing the other.

Primarily, Chase's pastels feature figures, with landscapes or interiors as backgrounds, though he also rendered some sensitive still lifes. In the mid-1880s, a number of artists pointed out that Chase, despite his wide-ranging talents, had never depicted the nude. His answer was a series of pastels, including *Back of a Nude*. The work demonstrates his dual talents at depicting the female form and at manipulating pastel for texture, space, and atmosphere. Rendered with precision, the figure has a graceful outline that owes something to the art of Ingres. At the same time, Chase's handling, using a gentle, rhythmic layering of strokes, conveys the suppleness of the figure's ivory-toned back. Though he worked with a posed model, Chase has tilted her head to give the work a casual feeling.

Chase's fascination with Japanese art is immediately apparent in this pastel. A folding screen forms the backdrop, but where its perimeters lie is left undefined. This spatial ambiguity provides a quiet contrast to the crisp lines of the nude. The indistinct patterns in the screen are echoed in the abstract print of the fabric around the figure. The placement of a figure up against the picture plane, as it were, the silhouetting of her form, the steep rise of the floor, and the screen's compression of the spatial scheme are compositional devices typical of Japanese prints. These devices had also been employed by the French Impressionists in their effort to escape from academic pictorial conventions.

Back of a Nude demonstrates Chase's ability to synthesize classical influences and modern inventiveness. "The delicate feeling for color and for value, the masterly handling of the material, the charm of texture in skin or stuffs—these things we were prepared for," Chase's friend the painter Kenyon Cox said, "but we were not quite prepared for the fine and delicate drawing, the grace of undulating contour, the solid constructive merit which seemed to us a new element in his work."

Pastel on paper, 18 × 13 in. (45.7 × 33 cm). Collection of Mr. and Mrs. Raymond J. Horowitz

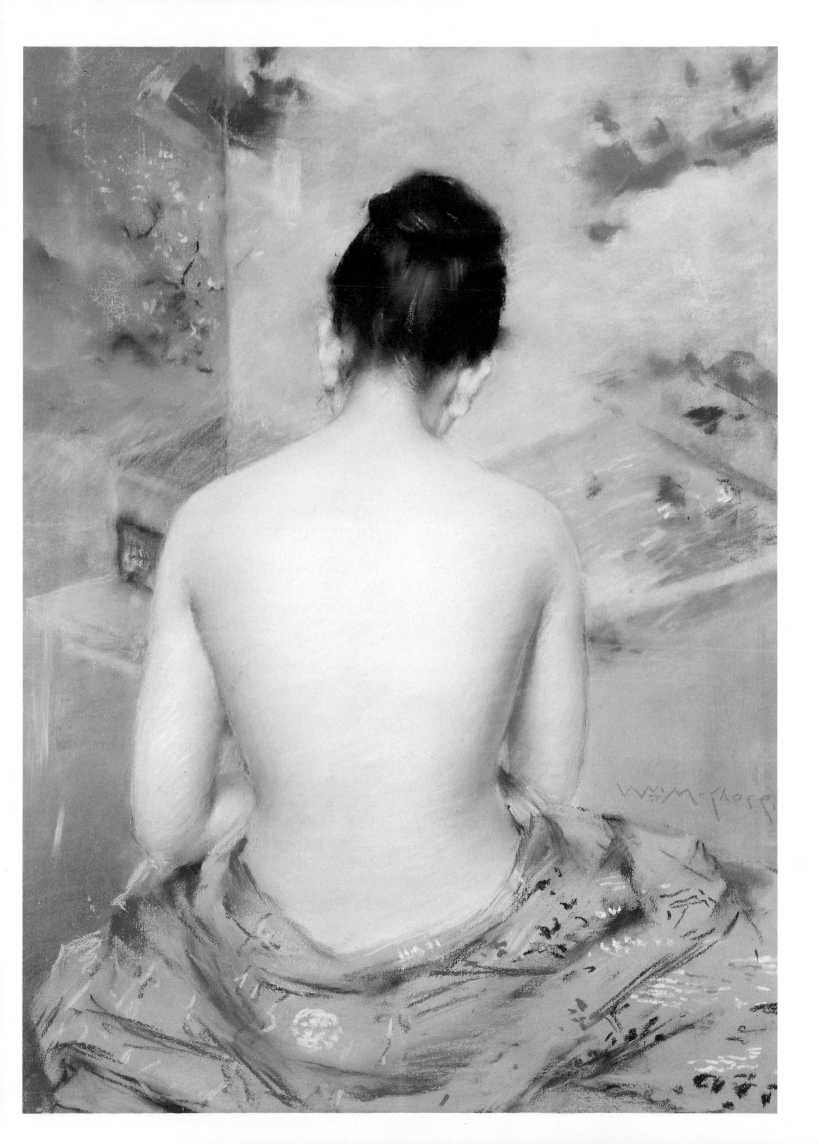

WILLIAM MERRITT CHASE
1849–1916

Prospect Park, Brooklyn, late 1880s

During the early 1880s, William Merritt Chase created an important group of paintings depicting his ornately decorated New York studio. Filled with artwork and carefully selected antiques, his studio views reflected his cosmopolitan life-style. After his marriage to Alice Gerson in 1886 and their move to Park Slope, Brooklyn, Chase turned his attention to the public parks of New York, capturing the contentment of his new domestic experience.

From his home, it was a short walk to Prospect Park, where he set up his easel on summer afternoons. Abandoning the dark, tonal style of his studio paintings, he began to record effects of sunlight and shade falling across broad lawns, gravel walkways, and figures sitting on park benches. Chase first evolved an Impressionist style in his park paintings, adopting a bright chromatic palette and spontaneous brushstrokes to record forms in the open air. During the late 1870s, following a period of study in Munich, Chase had been one of the earliest American artists to exhibit works rendered in a sketchy, unfinished manner, and his "Impressionism" evolved naturally from his love of painting directly. Rather than turning motifs into flickering dabs of color, as Claude Monet had done in his paintings of Parisian parks, Chase used a more conservative technique. As may be seen in *Prospect Park, Brooklyn*, he maintains strong divisions of dark and light, carefully structuring his image to express the refined order of the park's design. Whereas Monet used an aerial perspective in his 1876 scenes of the Tuileries Gardens, portraying them as a confusing variety of overgrown plants and dizzying passageways, Chase adopts a low vantage point that gives the Brooklyn park a feeling of inviting accessibility.

The park, which had been designed during the late 1860s by Frederick Law Olmsted and Calvert Vaux, provided a ready-made subject for Chase, and his paintings of it celebrate the vision of its planners. Olmsted and Vaux had organized the green enclave in the midst of urban Brooklyn to enhance a visitor's enjoyment of nature. The park gave the appearance of being natural, but it was actually highly planned, with passageways leading to a series of vistas demarcated by classical structures, well-placed groves of trees, and ponds for pleasure boating. The landscape was adjusted to a human scale and ordered so as to encourage interaction between fashionable strollers and afternoon leisure-seekers.

Chase capitalized on the park's natural beauty and avoided any discordant or disagreeable notes. He never depicted it on rainy, or even cloudy, days, and he included only its most picturesque and civilized aspects. Because men rarely appear in them, and are always in the background when they do, the works have a domestic atmosphere. His views of Prospect Park and later of Central Park presented public life, yet they were a direct reflection of the artist's private experience, expressing a feeling of harmony and balance and a coalescence of nature, family life, and art. Chase would maintain this attitude during the coming years, expressing it in his vibrant depictions of his wife and children enjoying the landscape of Shinnecock, Long Island.

Oil on canvas, 17³/₈ × 22³/₈ in. (44.1 × 56.8 cm). Colby College Museum of Art, Waterville, Maine; Gift of Miss Adeline F. and Miss Caroline R. Wing

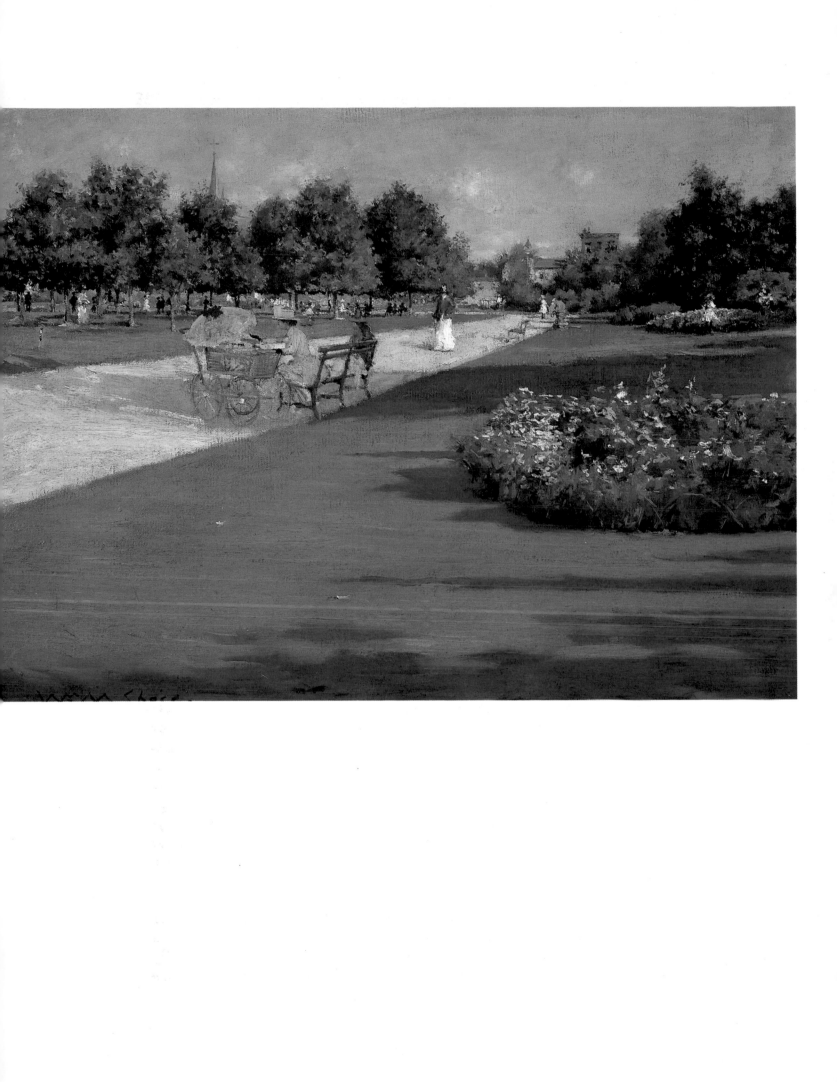

WILLIAM MERRITT CHASE
1849–1916

Idle Hours, *ca.* 1894–95

Well established as a teacher at the Art Students League in New York City and praised for his scenes of Prospect and Central Parks, William Merritt Chase was one of America's best-known artists in the early 1890s. It was at this time that Mrs. William Hoyt, an amateur painter and summertime resident of Southampton, Long Island, proposed that he establish an art school in the nearby Shinnecock Hills. Funded by two prominent citizens, the school offered instruction during the summer, when most city art schools were closed. At those schools, students drew from casts and did figure studies in studios; Shinnecock, in contrast, was an open-air school. As an 1897 article reported, "there is the absence of dust, noise, and turmoil, and some of the very best work of the whole year is accomplished."

Chase's own conversion to Impressionism coincided with his involvement in outdoor teaching and open-air work. The Shinnecock landscape was not scenic in the traditional sense, neither dramatic nor awe-inspiring, yet full of color and atmosphere. The gentle roll of the terrain, its modulated tones, the shifting patterns of the clouds, and the glimpses of sparkling blue water in the distance were the ideal vehicles for Chase's technical versatility, and his pleasure in capturing the landscape's subtle variety is obvious in the many canvases created during his summers on the coast.

Chase's method was to set up a comfortable stool and "paint the picture on the spot." He never used an umbrella because, as he told the writer A. R. Ives in 1891, "I want all the light I can get." Chase practiced what he taught. As Ives reported, he told his students:

you must be right under the sky. You must try to match your colors as nearly as you can to those you see before you, and you must study the effects of light and shade on nature's own hues and tints. You must not ask me what

color I should use for such an object or in such a place; I do not know until I have tried it and noted its relation to some other tint, or rather if it keeps the same relation and produces on my canvas the harmony which I see in nature.

Chase had adopted a direct style as a student in Munich in the early 1870s, a style inspired by Velázquez. At Shinnecock, he combined his vigorous handling of paint with a brilliant palette, and forged an Impressionism in which he distinguished between the different tactile qualities and textures in nature by adjusting his brushstrokes. For Chase, Impressionism served as a way of enhancing expression and conveying the spirit of a specific place, rather than as a vehicle for experimentation.

The Shinnecock experience is exemplified in *Idle Hours*, in which the artist's wife and children, dressed in white, informal attire, enjoy an idyllic afternoon. There is a lack of contrivance in their poses, especially in comparison with the children in carefully planned, elaborate works such as Sargent's *Carnation, Lily, Lily, Rose*. The landscape is similarly a straightforward, honest record of the dry, brushy ground cover, the smooth sand, the clear sky, and the thick cloud at the left. The openness of the site, the broad curve of the empty beach, and the undramatic landforms invite the viewer to feel the Chase family's contentment. William Howe Downes summed up Chase's Long Island landscape work as having "a character of precise, candid objectivity, and a cheerfulness that is infectious. The scenes painted in the Shinnecock Hills . . . give forth an aroma of summer holidays in a most paintable region of dunes, breezes, wild flowers and blue seas."

Oil on canvas, 25 × 35 in. (63.5 × 88.9 cm). Amon Carter Museum, Fort Worth, Texas

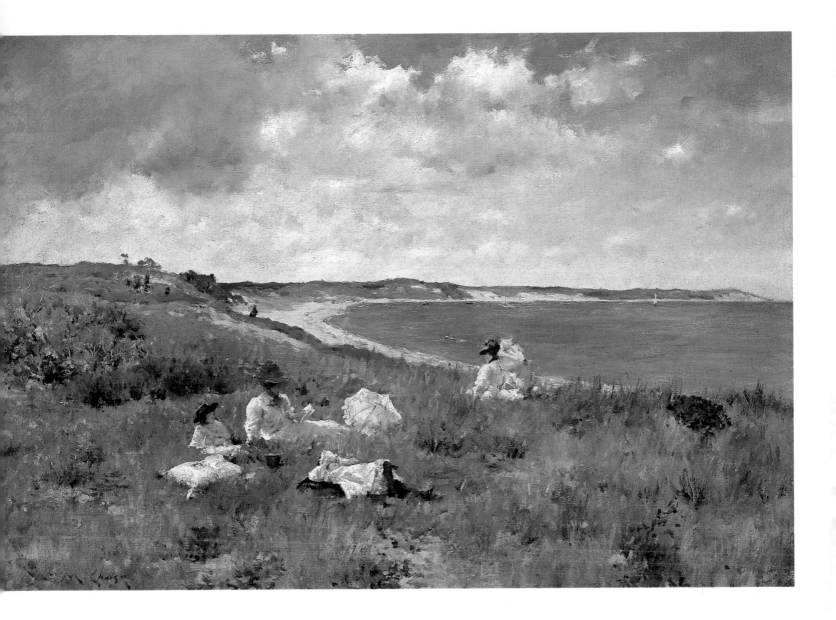

WILLIAM MERRITT CHASE
1849–1916

A Friendly Call, 1895

Shinnecock, Long Island, inspired William Merritt Chase's finest landscapes, many of which featured his wife and children relaxing on sunny, sandy hillsides with their long, horizontal house in view in the distance. Designed by Stanford White in the Shingle Style, this house was built on an open plan, its wide hallways leading to high-ceilinged, spacious rooms.

During the summer of 1891, the year Chase opened an art school at Shinnecock, the family stayed at a local inn. The next year, they moved into the house, and the artist began to capture in oil paintings and pastels its light-filled spaces, tasteful and minimal furnishings, and walls adorned with pictures. Including his family in these works, Chase portrayed the house as a place for everyday living and for the appreciation of art as well. Executed in 1895, *A Friendly Call* displays Chase's ability to integrate these two aspects of his summer house. The artist's wife, at the right, has received the caller in his studio, a square room at the west end of the house. A mirror behind Chase's wife reflects a wall of the studio and the stairwell and hallway beyond: an homage to Velázquez, who used a similar compositional device in his famous *Las Meninas* (in the Prado, Madrid). This arrangement expressively conveys the free flow of movement in the house and reveals how its many windows flooded the house with natural light.

Since the late 1870s, his studio had been a favorite subject for Chase. His workspace in New York City, on Tenth Street, was sumptuously filled with his canvases and with "treasures gathered together from half the curiosity shops of the old world" (as one writer put it in 1891), and was the subject of paintings in which Chase celebrated his eclectic interests. *A Friendly Call* is about other sources of Chase's art: family and friends. Photographs from the time do reveal that the Shinnecock studio was far more cluttered than it appears in *A Friendly Call*; indeed, Chase has even omitted the tools of his trade. Placing pillows and artwork in neat arrangements, creating a balanced composition in pastel tones, Chase turns the studio into a sitting room for genteel socializing.

A Friendly Call is not a traditional genre scene, but it hints at a narrative. The caller, wearing a showy veiled hat and gesturing assertively, contrasts with the artist's wife, who is quietly at ease, her simple dress and the Japanese fan in her lap in accord with the room's understated refinement. Still, the figures are treated as part of an over-all scheme conveying the harmony between the personal and the artistic spheres.

Oil on canvas, 30¼ × 48¼ in. (76.8 × 122.6 cm). National Gallery of Art, Washington, D.C.; Chester Dale Collection

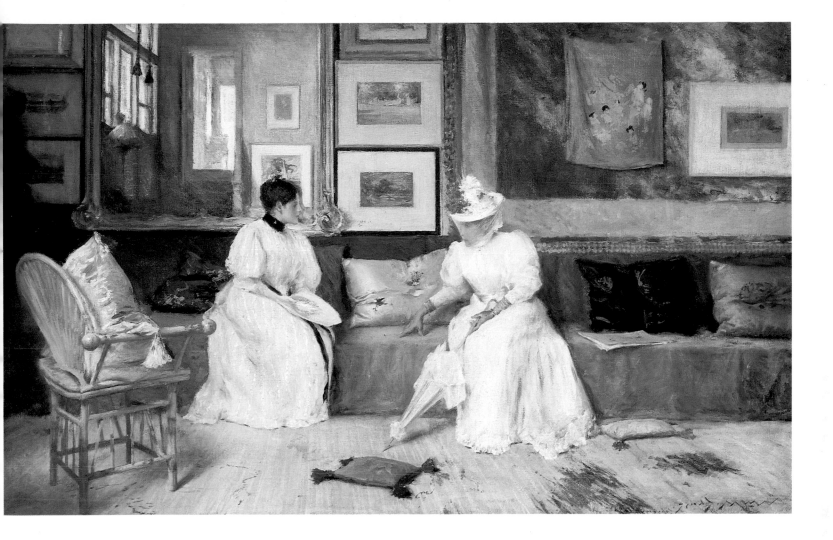

CHILDE HASSAM
1859–1935

Le Jour de Grand Prix, 1887

Among the American Impressionists, only Childe Hassam consistently portrayed the urban scene. His interest in the subject predated his years as an Impressionist. Early in his career as an illustrator and later a watercolorist, and after his first trip to Europe, in 1883, he began to render scenes of Boston's Columbus Avenue, a broad thoroughfare lined with fashionable brownstone buildings. Hassam's views of Boston recall the Paris he had recently visited, which had been redesigned over the previous two decades by Baron Haussmann, at the behest of Napoleon III.

Hassam continued to make city life his subject during an extended stay in Paris, from 1886 to 1889, when he must have become aware of the works of the French Impressionists. His canvases gradually began to reflect their influence. *Le Jour de Grand Prix*, one of the earliest of these, is also one of his best-known, most refreshing paintings. The sunlit, exuberant scene suggests his youthful enthusiasm for the cultural capital, his delight in the Parisians' daily devotion to entertainment, fashion, and leisure.

The painting depicts carriages on a recently widened boulevard on the day of the Grand Prix, an annual horse race that took place in late June. The event was held at the Hippodrome de Longchamp, a racecourse built in 1857 in the Bois de Boulogne, a vast park relandscaped by Haussmann. As Robert Herbert recently noted, the races "were at the center of an elaborate social arabesque for the upper class, involving balls and parties . . . new fashions in clothing, new or newly furbished equipages for horses and carriages and promenades to and from the Bois."

Le Jour de Grand Prix presents the traffic as a parade, probably returning home, in different directions, at the end of the day, continuing the spectacle of the race. The carriage on the left, a large four-in-hand (pulled by a four-horse team), towers over the other vehicles behind and beside it. This grand carriage, which was probably rented, had two functions: it allowed one to view the race from its elevated seats; and it would impress the crowds standing below. On the carriage's upper deck, the five parasols and four top hats that are visible may not represent the total number of racegoers in the party. Hassam accentuates this vehicle's impressiveness; it dominates the traffic. The broad open space in front of it gives it a commanding presence that contrasts with the congestion in the opposite lane. Spectators line the sidewalk on the left; undoubtedly a similar crowd stands at the right with the viewer, who thus becomes part of the audience.

Rendered with flecks of various colors, the trees are the most Impressionistically treated elements in the work. They provide a soft contrast to the stark, light-struck pavement and, used compositionally as a screen, they divide the boulevard from the urban sprawl beyond and draw the eye along the diagonal axis on which the scene is organized. A triumphal arch on the left, through which the carriage apparently has travelled, suggests the classical grandeur of the past, while the building on the right, with its mansard roof, represents the elegance of Second-Empire Paris; in implying a great sweep from one structure to the next (the only two buildings in the composition), Hassam perhaps comments on the continuity of French artistic tradition.

Oil on canvas, 36 × 48 in. (91.4 × 121.9 cm). New Britain Museum of American Art, New Britain, Connecticut; Grace Judd Landers Fund

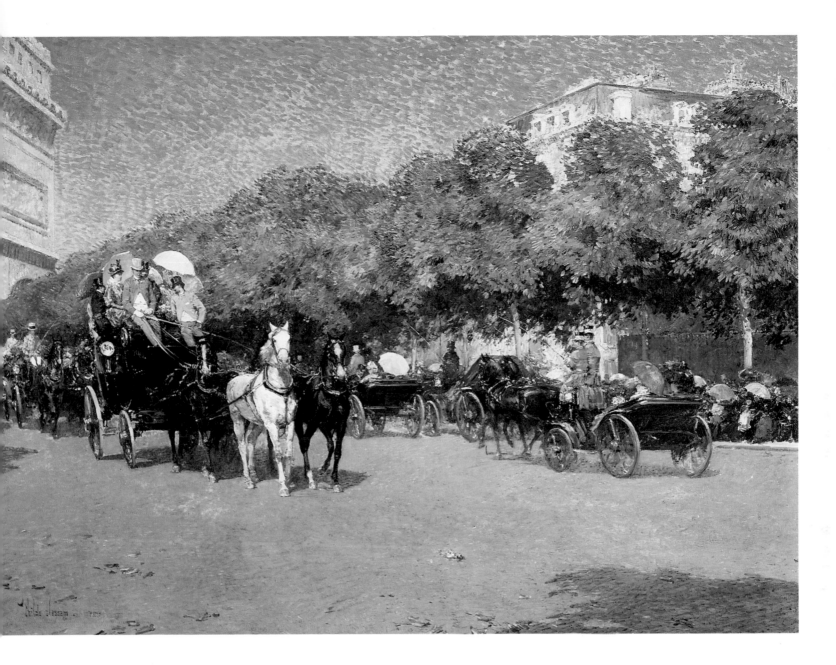

CHILDE HASSAM
1859–1935

The Garden in Its Glory, 1892

Beginning in the mid-1880s, Childe Hassam spent summers on Appledore, one of the Isles of Shoals, ten miles off the coast of New Hampshire. Over the next three decades he would create approximately one-tenth of his oeuvre there, including many of his best oil paintings, watercolors, and pastels. Despite its distance from Boston and New York, Appledore drew a sophisticated community of artists, writers, and musicians, attracted to the island by a poet and amateur artist, Celia Thaxter, who was famous for a garden that spread along the coastline, and who ran an informal salon. Thaxter had briefly been a student of Hassam's, but on Appledore she became his mentor, encouraging his development. The brilliant colors and tangled masses of her garden encouraged Hassam to experiment, spurring his conversion from a studied style, influenced by his background in commercial illustration, to a full-fledged Impressionism.

Many of Hassam's finest Appledore images were watercolors. His early works in this medium had been realistic images in the English tradition of topographic views. Gradually, he developed the atmospheric and expressive new vocabulary evident in watercolor works like *The Garden in Its Glory*, which was one of a number of Hassam's illustrations for *The Island Garden* (1892), Thaxter's book about her Appledore garden. Hassam's images captured the spirit of Thaxter's chronicle of the seasons: "Open doors and windows," Thaxter wrote, ". . . out on the vine-wreathed veranda, with the garden beyond steeped in sunshine, a sea of exquisite color swaying into the light." In *The Garden in Its Glory*, the author and her grandson stand in just such an open door, and the dark, cool interior from which they emerge heightens the sensation of

their encounter with the brilliant maze of plantings that embrace the house in their abundance. Hassam's dynamic yet delicate brushstrokes seem to entice the two figures into the garden's depths as they draw the viewer up through the garden's growth, with the varied rhythms of its handling, to the doorway.

Monet had used a similar composition in paintings of his house and garden in Vetheuil, France, that Hassam might have seen when they were shown in New York in 1886. Monet arranged his figures along a long stairway and conveys a feeling of movement. In contrast, Hassam's figures, framed by the door and crowned by an arching trellis, take on a static, iconic quality. This is more than a vivid impression of a sunlit scene; Hassam is paying tribute to Thaxter's roles as creator and muse.

In *The Garden in Its Glory*, flowers rise up along the sides of the stairs to the house, yet the way is clear enough to allow passage. The trellis encourages the vines to spread, and at the same time gently restrains them. Thaxter's gentle caretaking gave definition to the garden, setting out its perimeters while allowing it to grow freely within them. Hassam's spontaneous brushstrokes parallel Thaxter's gardening approach, tempered as they are by his technical confidence and refined sensibilities.

Watercolor on paper, 19¹⁵/₁₆ × 13⅞ in. (50.6 × 35.2 cm). National Museum of American Art, Smithsonian Institution, Washington, D.C.

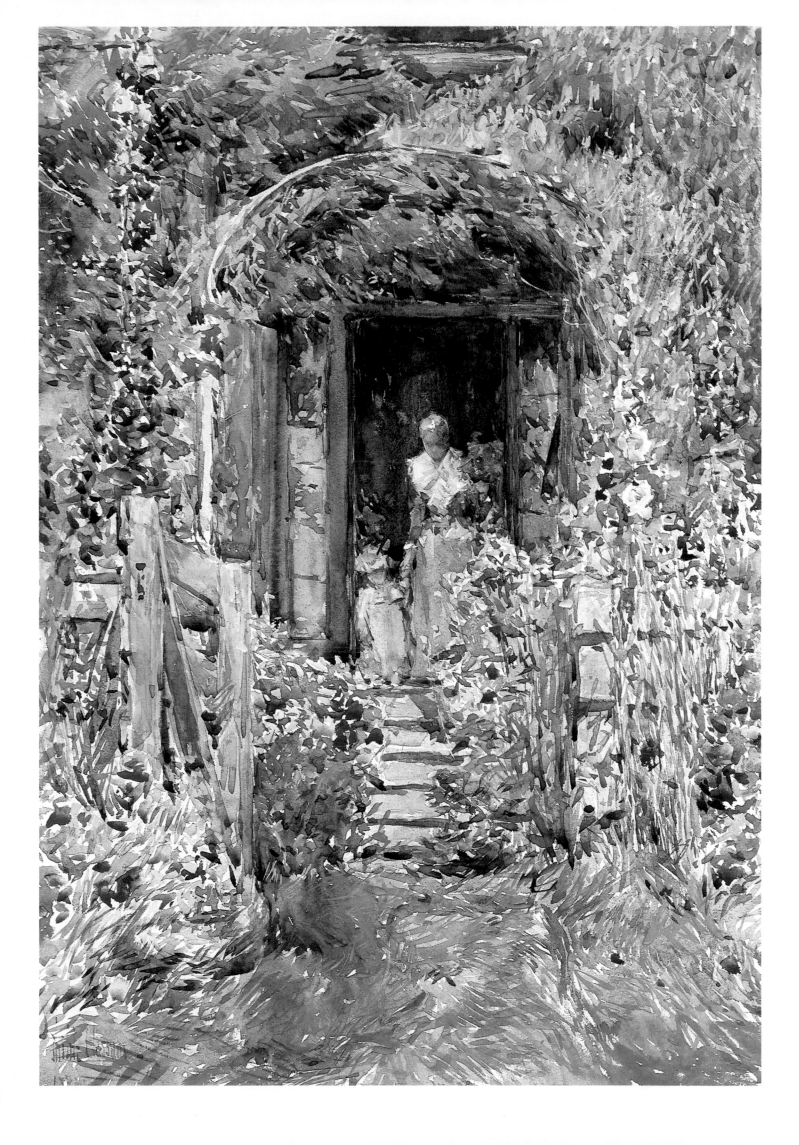

CHILDE HASSAM
1859–1935

Late Afternoon, New York: Winter, 1900

In 1889, after returning from his second trip to Europe, Childe Hassam settled in New York, where he enjoyed a productive and satisfying career and was active in the important art associations of the era. He showed works at the National Academy of Design and the Society of American Artists. In 1897, along with other New York and Boston artists, many of whom had adopted the Impressionist aesthetic, he seceded from the latter organization and helped to found the group called Ten American Painters. During the group's twenty-one years of existence, Hassam participated in all but one of its annual shows, demonstrating the great range of his art in rural and coastal landscapes, foreign scenes, interiors, figures, and scenes of city life, a subject which he had begun to paint during the late 1880s in Boston and which remained a dominant one.

Living at 95 Fifth Avenue, near Union Square, during the first decade of the twentieth century, Hassam was able to depict the urban life he viewed from his studio window. There, it was particularly easy for him to capture the city in the throes of midwinter storms. By 1900, when he rendered *Late Afternoon, New York: Winter*, he had been influenced by Monet's and Pissarro's depictions of Paris on snowy days. For Hassam, however, the city in winter expresses a different mood. In works such as Monet's *Boulevard des Capucines*, 1873–74 (in the Nelson–Atkins Museum, Kansas City, Missouri), figures and traffic, seen from overhead, appear to scatter in all directions, conveying a feeling of the city's tense energy even on an icy day. Hassam's lower angle of vision in *Late Afternoon, New York* draws the viewer more gently into the scene, toward distant forms that disappear into an atmospheric haze. Although carriages and pedestrians move quickly, there is not the sense of flurry and congestion that Monet presents; the movement is consistent with the viewer's angle, and the open space between vehicles and figures is readily discernible.

Despite the heavy snowfall that blurs the distinction between sidewalk and street, Hassam reinforces the diagonal of the avenue through an orderly progression of forms. The bare trees, maintained by iron supports, delineate the perspective, their rhythm quickening as they recede. In the middle distance, a lantern's faint glow points the viewer to an indistinct glimmer in the left background that represents another lighted lamppost. Buildings appear as shimmering specters in the distance, with touches of pale yellow representing the glint of windows. Hassam also conveys a feeling of harmony and tranquility by limiting the range of his tones and their values: lavenders, light blues, and mauves prevail, demonstrating his growing awareness, as an Impressionist, of color and light, even on a sunless day. His forms, too, are far looser than those in his earlier Boston scenes, which had reflected the draftsmanship acquired in his training as an illustrator.

Hassam's winter scenes have been compared to the contemporary photographs of New York on hazy winter days taken by Alfred Stieglitz. The loneliness and alienation expressed in Stieglitz's views are absent from Hassam's; like his colleagues John Henry Twachtman and Willard Metcalf, Hassam captures the season's poetry, conveying the same positive attitude toward a wintry America that he expresses in his sunlit summer landscapes.

Oil on canvas, 37 1/4 × 29 1/8 in. (94 × 73.6 cm). The Brooklyn Museum; Dick S. Ramsay Fund

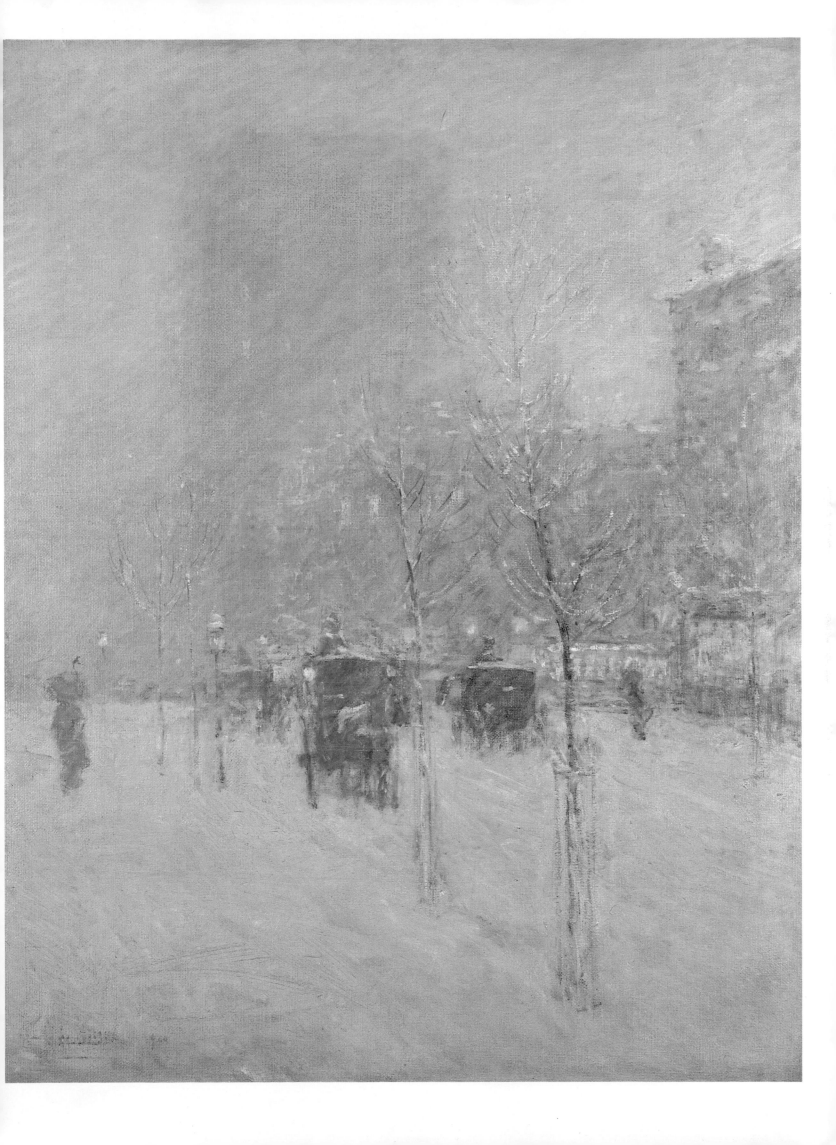

CHILDE HASSAM
1859–1935

The Avenue in the Rain, 1917

By World War I, Childe Hassam had devoted two decades to painting New York City, capitalizing on its picturesque streets and fashionable squares. A new mood, energetic and dynamic, emerges in the well-known paintings of Manhattan buildings bedecked with flags that he created from 1916 to 1919.

He began his flag series even before America entered the war, and did not complete it until the final parade, celebrating Victory Day. The series attests to Hassam's constant support for the war effort and his championing of the allegiance among the Allied nations. Avoiding the many parades and demonstrations held during the war, he preferred to show flags as part of the daily experience of his countrymen. He also chose to depict only scenes of Fifth Avenue and nearby streets, where the city's tallest and most elegant buildings were concentrated, avoiding areas of the city that were less majestic. Uniting the flag with the skyscraper, a symbol of American ingenuity, enterprise, and technological prowess, Hassam fortified its patriotic message.

Many of the flag paintings were rendered with free and vigorous brushwork. *The Avenue in the Rain*, also known as *Flag Day*, is the most abstract of Hassam's flag images; at the same time, it is among the most monumental. The rectangle of the flag is repeated in the canvas's format. The elongated vertical shape gives the work an especially elegant and refined look.

Hassam had painted scenes of rainy days during the early 1880s in Boston, delighting in slick streets and hazy skies and relying on softly modulated tones to express subtleties of light and atmosphere. However, the somber quiet of these views is nowhere evident in *The Avenue in the Rain*. Wet surfaces are treated with rich shades of lavender, aqua, vermilion, royal blue, and white. With the exception of a couple of dots of yellow, variations on the three colors of the flag are the only ones used in the work. Hassam capitalizes on these colors' reflections in the street and permeation of the misty atmosphere. A sense of quick movement, established with vigorous brushwork, contributes to a feeling of excitement. Flags recede in a dancing pattern, leading in a sinuous line down the avenue. Their progression into the distance contrasts with the forward motion of pedestrians, contributing to the feeling of vitality and energy that the work expresses. Like a note of victory sounded in the distance, a flag atop a building stands against a brightening sky.

In the catalogue for a recent exhibition of Hassam's flag paintings, *The Avenue in the Rain* was called one of the artist's most Impressionistic paintings. The work is indeed the closest of his series to Monet's images of flags and crowds, painted in 1878. Yet despite its lively flurry of figures and bright banners, Hassam omits the frantic intensity of Monet's depiction. The soft blending of colors, shapes, and tones expresses a positive message while conveying the city's aesthetic pleasures. Although Impressionism had originated in France in the late 1860s, by the early twentieth century it had come to be seen as an American style, expressive of dynamic and beautiful qualities in American life. In his scenes of colonial churches in New England and of sparkling coastal landscapes, Hassam adapted the Impressionist aesthetic to the depiction of the best of the American experience. It is indeed fitting that this painting belongs to the White House.

Oil on canvas, 42 × 22¼ in. (106.7 × 56.5 cm). The White House, Washington, D.C.

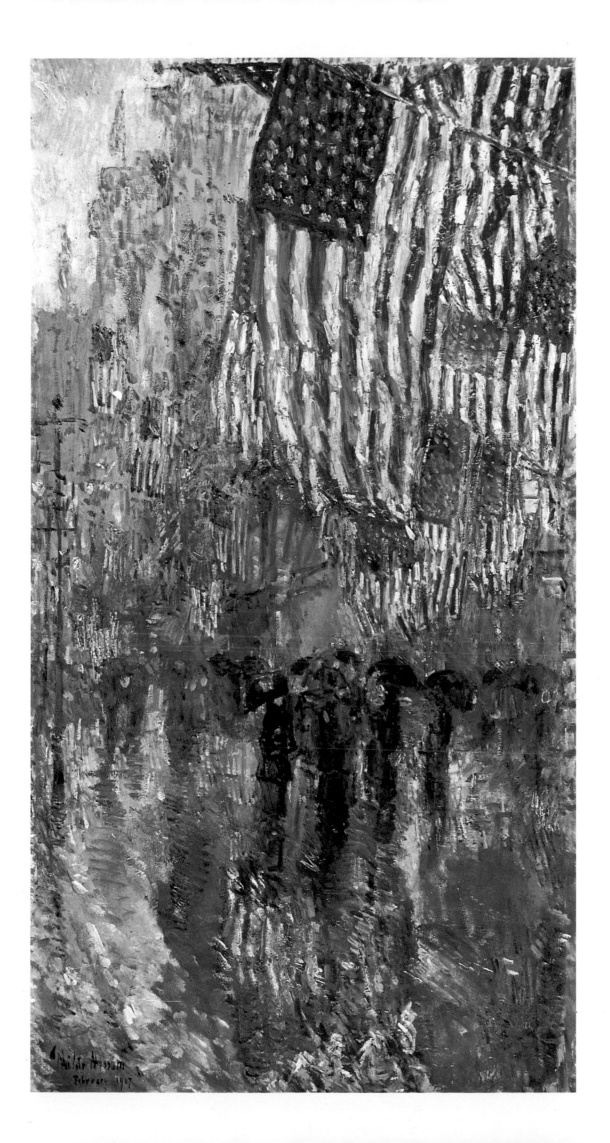

JOHN HENRY TWACHTMAN
1853–1902

Winter Harmony, ca. 1890–1900

Revered by fellow artists as a "painter's painter," Cincinnati-born John Henry Twachtman was in the avant garde throughout his career. A student in Munich in the mid-1870s and in Paris in the early 1880s, he then settled in Greenwich, Connecticut, where he developed an Impressionist style inspired in part by his friend Theodore Robinson, who had spent many summers close to Monet, and in part by French Impressionist art that he saw in New York galleries. Yet Twachtman's Impressionism also evolved from his earlier artistic explorations, and his mature aesthetic was tempered by his personal response to nature and by his versatile technique.

Like Monet, Twachtman discovered infinite possibilities in familiar scenes, and his Greenwich house and property—almost seventeen acres, which he accumulated between 1889 and 1891—provided him with subject matter for the rest of his life. Almost all his Greenwich canvases present his house, a brook that wound through his property, a waterfall, and a small pool surrounded by hemlock trees that is the subject of *Winter Harmony*. Although he kept returning to these images, Twachtman did not create works in series, unlike Robinson, who followed Monet's example in this regard. His paintings express his joy in the countryside, a pleasure in sites whose changing moods he knew well. Looking at his landscapes, as his friend J. Alden Weir aptly noted, one feels "the spirit of the place and the delight with which [Twachtman's] work was done."

Most other artists worked in urban studios during the winter, but Twachtman painted outdoors throughout the year. Like Dennis Miller Bunker, he worked best far from the bustle of the city. In an

1891 letter to Weir, Twachtman wrote, "To be isolated is a fine thing and we are then nearer to nature. I can see how necessary it is to live always in the country—at all seasons of the year."

Working on-site, Twachtman executed sensuous images of nature that capture subtle nuances, including imperfections, with a special, tactile quality. Twachtman was sensitive to the characteristics of each season, but winter fascinated him especially. Of his Greenwich works, the best known depict a snowy landscape. He took pleasure in scenes in which patches of bare ground emerge from melting snow. In *Winter Harmony*, however, he presents a still, icy midwinter day. A misty atmosphere envelops the scene, and the pool, covered with a thin sheet of ice, seems to hover at the center of the work. Twachtman enhances the feeling of serenity by eliminating the horizon line and focusing on the pool in the middle ground. Trees on each side of the pool center one's attention and enhance the stasis and meditative tranquility. "We must have snow and lots of it," Twachtman told Weir. "Never is nature more lovely than when it is snowing. Everything is so quiet and the whole earth seems wrapped in a mantle. That feeling of all nature is hushed to silence."

Oil on canvas, 25 ¾ × 32 in. (65.4 × 81.3 cm). National Gallery of Art, Washington, D.C.; Gift of the Avalon Foundation

JOHN HENRY TWACHTMAN
1853–1902

The White Bridge, ca. 1895–97

Around 1889, John Henry Twachtman and his family moved to a small eighteenth-century farmhouse in Greenwich, Connecticut. As his family grew, Twachtman added dormer windows, porches, and extensions to the front and back. Conscious of the intrinsic properties of the site, he adjusted each addition to the slope of the land so that the house eventually appeared to be a natural outgrowth of the landscape. Twachtman's approach to his house parallels his approach to painting. He accepted the beauty of the terrain and let it determine his home's design. In his art, he also painted subjects for the beauty he found in them, without exaggerating their picturesque qualities.

In the mid-1890s, Twachtman built a white footbridge across a section of Horseneck Brook, which wound through his property. He may have constructed the bridge for practical purposes, but he was surely aware of the aesthetic opportunities it would provide. Its latticework and its graceful arch complemented the surrounding landscape and gave to the wildness of this area a civilized touch that mirrored his domestic life. The vision of this delicate bridge inspired around five paintings of considerable variety. In *The White Bridge*, the most elegant and decorative of the five, the central motif is enfolded in lush, fresh foliage. Pale yellows, greens, and blues, applied with smooth brushstrokes and colored glazes, express the jubilant feeling of the artist on seeing the familiar landscape in spring.

Motifs are seen through and screened by other motifs. The knobby, greening branches of a tree in the foreground winnow our view of the bridge, and the bridge's lattice railing screens that of the trees beyond. Twachtman's interest in this type of pattern and in asymmetrical design reveal his debt to Japanese prints, which he studied closely during his years in Greenwich.

Interestingly, the painting shows a few parallels with Monet's depictions, at the turn of the century, of the Japanese footbridge over his Giverny lily pond. Yet Monet's bold and direct views differ from the delicate interweaving of forms employed by Twachtman, and his investigation of the effects of sunlight on his subject also contrasts with the gentle and evocative color of Twachtman. Indeed, contemporary critics noted how different Twachtman and his close friend J. Alden Weir were from their French counterparts. An 1893 show that included paintings by Twachtman and Weir, alongside an exhibition, in the same gallery, of pictures by Monet prompted the *New York Sun* to report that while the two Americans, like Monet, "have striven toward the expression of Impressions of landscape and figure, they have looked with soberer eyes. There is none of the splendid, barbaric color that distinguishes the works of the Frenchman. They tend to silvery grays modified by greens and blues quite as silvery." Twachtman, uninterested in strong, saturating sunlight, was drawn to the subtleties of hazy days and filtered light, and even more by aesthetic qualities in nature not immediately apparent to the causal viewer. A highly original nature poetry is conveyed, especially, in his unconventional formal arrangements. The movement of the glistening, rushing brook is counterbalanced by the orderly intersection of verticals and horizontals. The painting captures both the liveliness of springtime and the serenity of the warm days it heralds.

Oil on canvas, 30¼ × 30¼ in. (76.8 × 76.8 cm). The Minneapolis Institute of Arts; The Martin B. Koon Memorial Collection

JOHN HENRY TWACHTMAN
1853–1902

Wild Cherry Tree, ca. 1901

During the last three years of his life, John Henry Twachtman spent his summers in the seaside town of Gloucester, on Massachusetts' Cape Ann, where he joined a number of colleagues and painted some of his most vibrant and strikingly modern canvases. A place to which vacationers thronged during the late nineteenth century, it was also a prominent gathering place for artists, especially Impressionists, who stayed in its residential hotels and painted from its piers and hills. Childe Hassam visited Gloucester as early as 1890, and Willard Metcalf executed his vivid harbor view there in 1895. In 1898, Theodore Wendel settled in nearby Ispwich. Gloucester's sunny climate, jagged shores, and scrim of piers made it a natural inducement to their delvings into Impressionism. Both Joseph DeCamp and Frank Duveneck traded their dark palettes for brilliant ones while they were on Cape Ann.

One reason Twachtman spent these three summers in Gloucester was that his old friend Duveneck was there; the two rarely had a chance to see each other, since Twachtman lived in Greenwich, Connecticut, and Duveneck in Cincinnati, Ohio. During their stay in Gloucester, Twachtman may have encouraged Duveneck's forays into Impressionism, and Duveneck may have encouraged Twachtman to return to the bold, *alla prima* approach of both artists' student days in Munich, in the 1870s. Twachtman, toward the end of the 1890s in his Greenwich paintings, had already begun to abandon his custom of layering and building up thick surfaces with colored glazes. In Gloucester, the sustained, laborious process of creating the appearance of spontaneity now yielded to a genuinely spontaneous method: he worked out his compositions entirely on the spot where he set his easel and left his brushstrokes freshly visible without retouching. He even allowed patches of the canvas to remain bare.

Wild Cherry Tree exemplifies the direct, seemingly effortless, and fully confident handling that Twachtman attained in Gloucester. The painting presents a view from East Gloucester's Banner Hill looking across Smith's Cove toward Gloucester. Yet rather than choosing the free and open vista that Metcalf had painted, Twachtman viewed the town through the softly fanning branches of the tree. Indeed, instead of painting the tree *over* an image of the scene beyond, he rendered both simultaneously, so that the leafy forms in the foreground blend with the flickering landscape. The exuberant brushwork does not obscure Twachtman's concern with design. The square canvas, a favorite format of his, is less compatible with the creation of an illusion of depth than with the patterning of the surface, and *Wild Cherry Tree*, revealing Twachtman's prescience, anticipates a time when artists emphasized the picture's surface and the expressiveness of paint and brushwork in themselves. Unfortunately, his further exploration of such abstract pictorial qualities ended as he died, suddenly, at the age of forty-nine.

Oil on canvas, 30 × 30 in. (76.2 × 76.2 cm). Albright–Knox Art Gallery, Buffalo, New York; Charles W. Goodyear Fund, 1916

JULIAN ALDEN WEIR
1852–1919

U.S. Thread Company Mills, Willimantic, ca. 1893–97

Born in West Point, New York, J. Alden Weir received his initial training from his father, Robert Weir, an instructor of drawing at the U. S. Military Academy. He continued his studies in New York at the National Academy of Design and in Paris at the École des Beaux-Arts, where he worked under the academic painter Jean-Léon Gérôme. Like Theodore Robinson, also a student of Gérôme, Weir developed skills at figure drawing and composition that would remain essential to his art. The major influence on his early career, however, was Jules Bastien-LePage, who had found a compromise between academic and plein-air painting by placing classically drawn figures—most commonly the peasants for which he became best known—in loosely rendered landscapes.

In Paris during the years of the first French Impressionist exhibitions, Weir, in a letter to his parents, called the 1877 show a "chamber of horrors." During the next decade, his close friends Twachtman and Robinson encouraged him to lighten his palette and begin to experiment with modern compositional ideas. By the early 1890s, he had converted to Impressionism, and by the end of the decade he was one of the Ten American Painters, a group with which he remained active throughout its existence.

U.S. Thread Company Mills, Willimantic (Connecticut) exemplifies the fresh and innovative aesthetic that Weir, free of academicism, formulated during the mid-1890s, his most experimental period. The work belongs to a series of canvases of a silk factory that Weir created from 1893 to 1903. Although enormous social changes were then taking place in America, as a nation of farms became one of factories, American landscapists of the era continued to depict, perhaps with nostalgia, peaceful rural areas.

Weir's decision to address a more modern landscape could have been prompted by his brother John Ferguson Weir's two 1860s paintings of foundry interiors; these genre scenes glimpsed men working by the light of molten metal. In contrast, J. Alden Weir's mills show no signs of labor and nestle harmoniously in a tranquil landscape: man's industry has not disrupted it. In fact, the scene recalls a type of European landscape of the Old Masters that featured fortresses and other ancient structures: the arched bridge in the foreground is reminiscent of a Roman aqueduct, and a chimney (emitting no smoke) suggests a picturesque tower. On seeing one of Weir's Willimantic works, Robinson noted in his diary, "I liked immensely a Conn. factory town, modern and yet curiously mediaeval in feeling. One feels that Dürer would have painted it that way."

Since Weir's scenes of Willimantic are his only industrial subjects, it appears that his interest in the site was aesthetic rather than cultural. His use of architectural elements to break up, or restructure, the landscape reflects his commitment to Impressionism, but also his interest in the principles of Japanese design. He owned at least fifty Japanese prints, which he studied carefully, and which may account for his use of a high view, the seeming pressure of forms against the picture plane, the asymmetrical design, and the silhouetting of elements within thin outlines. The result is that a decorative appeal is added to Weir's fresh, optimistic view of American progress, as coexisting with the countryside of an earlier, pastoral age.

Oil on canvas, 20 × 24 in. (50.8 × 60.9 cm). Collection of Mr. and Mrs. Raymond J. Horowitz; Partial and Promised Gift to National Gallery of Art

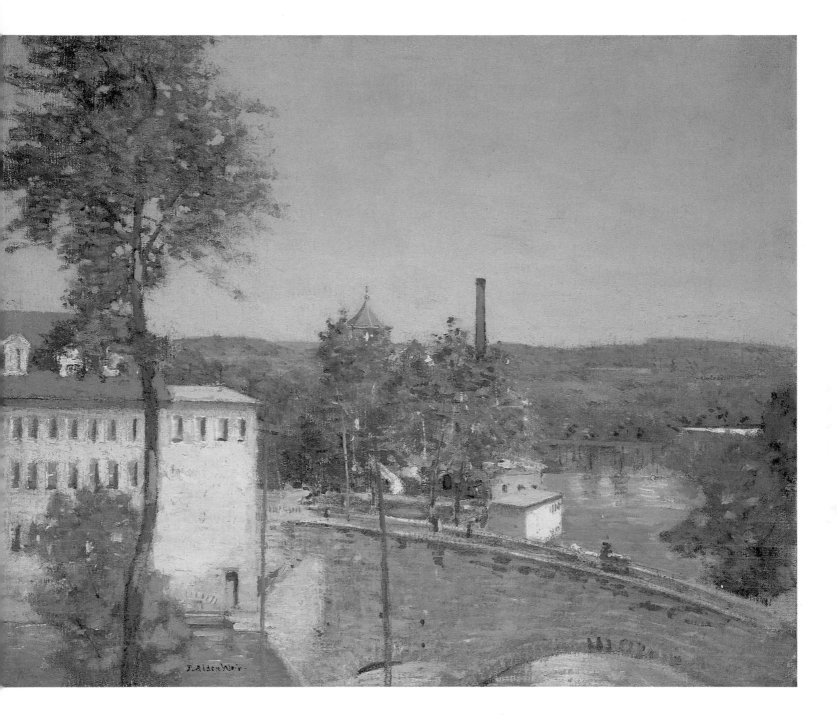

JULIAN ALDEN WEIR
1852–1919

In the Sun, 1899

Julian Alden Weir's early academic training under Jean-Léon Gérôme remained important throughout his career. By the 1890s, he was inspired by the Impressionists' broken brushwork and by the designs of Japanese prints to create his most adventurous works, but by the end of the decade he was back to the precepts he had been taught in art school. He finally settled on a style that synthesized classical and modern methods.

Weir's figural works from the turn of the century reveal his assimilation of contemporary artistic trends, such as spatial compression. *In the Sun*, a portrait of the artist's second daughter, Dorothy, emphasizes the flat picture plane as the figure's dress merges with the white rock behind her. The diagonal of her dress, the stylized foreground grasses, and the high horizon line reveal Weir's adoption of Japanese design, which breaks Western academic rules for locating a figure within a spatial illusion.

A female figure dressed in white and illuminated by sunlight was a favorite Impressionist subject, especially of Americans including Frank Benson, William Merritt Chase, Frederick Frieseke, Robert Reid, and Louis Ritman. Weir handles the effects of light by varying his brushstrokes and the thickness of the pigment to set off patches of brightness and shade. His background grasses are full of an Impressionist vitality.

While Weir's brushwork is animated, the consistency of his strokes displays control and decorative refinement. In fact, *In the Sun* is a carefully contrived image, classically suspended in time rather than expressive of a transitory moment. The figure is centered, and her pose is hardly casual. Her features are idealized and her hair, tightly curled, symmetrically frames her face and resists any breeze, unlike Benson's freer subjects in his *Portrait of My Daughters*. The girl's black hair ribbon strikes a calculated contrast with the whiteness of her dress. Her steady gaze, as she plucks a white lily emphasizes the stillness of her pose. The legacy of Weir's academic background is evident in this painting's methodical handling and artificial composition.

In the Sun balances two opposing aesthetics. Weir captures the sparkle of crisp white fabric in the sunshine and at the same time conveys his respect for the traditional lessons of the Old Masters.

Oil on canvas, 34 × 26⁷/₈ in. (86.3 × 68.2 cm). Museum of Fine Arts, Brigham Young University, Provo, Utah

EDMUND C. TARBELL
1862–1938

In the Orchard, 1891

For most of his career, Edmund Tarbell rendered images of women in luxurious, tranquil interiors, and it is for this subject matter that he is best known. It was for only a brief interlude that he executed outdoor scenes in an Impressionist style. *In the Orchard* is Tarbell's largest such canvas, as well as one of the most acclaimed and celebrated Impressionist paintings by an American.

Tarbell painted *In the Orchard* in 1891, five years after his return to Boston from Paris, where he had attended the Académie Julian. He probably became interested in the art of the French Impressionists then, and on his return home found his interest reinforced. During the late 1880s, a number of exhibitions were making French Impressionism familiar to Boston audiences. Moreover, American artists returning from European voyages had begun to champion the style.

Tarbell was assuredly inspired by his American colleagues; however, *In the Orchard* more closely approaches French examples than other images by native artists. Manet, Monet, Renoir, Cassatt, Morisot, and Caillebotte had all painted views of figures retreating from urban life in the beauty of the natural landscape. Tarbell's subjects are similarly fashionable urbanites transported to the country. Positioned casually, they converse and enjoy the fresh air. Sunlight filtering through the trees creates a dappled effect that Tarbell adeptly captures by interspersing soft greens with patches of brilliant yellows and pinks. The figure in white at the left stands partly in full sunlight, and Tarbell notes its effect on her dress with vigorous crosshatched strokes of pure, unmixed pigment. Colorful shadows add warmth to the image and reflect Tarbell's awareness of the basic precepts of the style he had adopted.

Although inspired by French works, Tarbell's *In the Orchard* has a distinctly American flavor. French artists had commonly presented figures enjoying nature from benches set on clear, sunlit pathways in ordered landscapes. In contrast, Tarbell replaces the formally planned garden with a woodsy orchard, where the grass has not been mowed. In the distance, a fence possibly demarcates a cow pasture, instead of a manor house or other emblem of civilization. The bench and the chair on which his figures sit are not part of a landscaped plan; the group has undoubtedly brought them to the orchard. Tarbell's uncultivated landscape reflects the wildness associated with the American countryside.

Tarbell's image also differs from French examples in that his figures are strongly delineated, rather than dissolved in light, as in the works of Monet. Although the seemingly unposed arrangement of the group contributes to the work's informal ambience, Tarbell tightly coordinates the relationships. A curving line may be followed throughout the grouping, beginning and ending with female figures dressed in white. A thin tree reinforces the vertical of the woman on the left and a broad branch extends over the more closely knit group on the right. The figure in blue is in a pivotal role at the center of the arrangement, looking toward the woman on her left, while her body is angled toward her companion on the right. Other aspects of the figures' poses contribute to the graceful network that connects them, as they share the delights of an August afternoon.

Oil on canvas, 60½ × 65 in. (153.6 × 165 cm). Herbert M. and Beverly Gelfand

EDMUND C. TARBELL
1862–1938

The Breakfast Room, ca. 1903

At the turn of the century, Edmund Tarbell continued the exploration of Impressionism that he had begun in the early 1890s, but he merged it with a return to a more traditional subject matter and style, reflecting his admiration for the Old Masters. Interiors rather than outdoor scenes were the primary vehicle for the new aesthetic he formulated.

While his paintings of figures in a landscape, such as *In the Orchard*, had reflected aspects of the art of Renoir and Monet, his turn-of-the-century interiors are akin to Degas's. In *The Breakfast Room*, Tarbell employs a number of compositional devices that were signatures of an Impressionist interpretation of modern life. The exaggerated tilt of the floor, the cropping of the table and the man at the left, and the concentration of action in the foreground present the abruptness and shifting of space that in French painting had come to represent the momentariness of contemporary experience.

As in certain paintings of couples by Manet, the relationship between the pair at the table is not clear. The two appear alienated from each other despite their close proximity. The man pauses in his repast to gaze toward the woman. His observation of her goes unnoticed as she concentrates on her reading. At the same time, her dress slips languorously off her shoulders, adding a provocative note, yet one countered by her pensive expression. When *The Breakfast Room* was shown in New York at the 1903 exhibition of the Ten American Painters, critics noticed its puzzling disparities. A *New York Times* reviewer commented that the painting was "a clever bit of interior . . . though why the lady should wear such [a] very low neck by the morning light does not appear." The art objects in the room augment the work's enigmatic polarities. Visible on the wall is one corner of a large canvas of a sprawling nude, painted in the style of Titian. The sensuality of this image contrasts with an Italian Renaissance-style marble bust on a window ledge that provides an opposing note of purity.

Despite the ambiguity in the work's motifs, the scene is infused with a mood of quiet leisure that relieves its tensions. This calm and the carefully ordered composition reveal Tarbell's regard for the work of the seventeenth-century Dutch painter Jan Vermeer. The controlled light that enters the main room from a side window in an adjoining room also derives from Vermeer. Tarbell uses the illumination in this sparsely furnished space to convey a feeling of comfort. With loose brushstrokes he gives a glimmer to the reflections in the polished floor. Paintings and other objects on display reveal the couple's refinement and appreciation for the Old Masters as well as for Japanese art. Furthermore, *The Breakfast Room* offers an image of a life of wealth, devoid of difficulty. The maid, in the next room, spares the couple the necessity of work. Framed by the doorway, she keeps her distance from them.

In the years ahead, Tarbell would continue to render images that suggest that art's purpose is to serve as a gentle antidote to the pressures of modern existence. He became the acknowledged leader of a group of Boston painters who preferred tranquil interiors, turning away from the images of public life and society that had been emphasized by French painters, and turning toward a world of privacy, spirituality, and introspection.

Oil on canvas, 25 × 30 in. (63.5 × 76.2 cm). Pennsylvania Academy of the Fine Arts, Gift of Clement B. Newbold, 1973

FRANK W. BENSON
1862–1951

Portrait of My Daughters, 1907

During the 1890s Frank Benson established his reputation in Boston for carefully wrought paintings of figures in subtly lit interiors: the products of his training as an academic painter and of his study of the seventeenth-century Dutch artist Jan Vermeer. Benson's good friend Edmund Tarbell had initiated a Vermeer revival, and Benson's works were often linked by critics with Tarbell's. After the turn of the century, however, their styles diverged, and Benson developed as the foremost American exponent of Impressionist, plein-air figural painting. During summers spent on North Haven Island, in Maine's Penobscot Bay, Benson created an important group of fluidly rendered paintings of his wife and children that expressed his love of them and of the coastal landscape.

Portrait of My Daughters depicts the artist's three daughters: the oldest, Eleanor, is at the right; the middle daughter, Elisabeth, is seated on a bench; and Sylvia, the youngest, stands behind them. Preoccupied, each is turned in a different direction yet casually shares in an enjoyment of the day's freshness and sunshine. The painting conveys the feeling of a relaxed life. As a reviewer for the *Boston Evening Transcript* wrote in 1908, "No one achieves such a sensation of a flood of warm, golden light, such an impression of vibrating atmosphere, such a feeling of freedom, joy and wholesome stimulation of vitality." Unlike the two women in William Merritt Chase's *A Friendly Call*, who continue citified activities in the country, the artist's three daughters evidence their mutual affection in a quiet moment.

Of the many American Impressionists who depicted women dressed in white, Benson was best able to convey effects of sunlight on their summery garments.

In *Portrait of My Daughters*, short, curving strokes and pure pigment animate the brighter surfaces of the dresses, and softer, more modulated patches depict the shadowed areas. Benson's figures and landscape do not dissolve in light; he is especially careful to maintain their solidity and delineate the faces. This characteristic of Benson's work has been traced to his years of academic study, but he did intend his North Haven works to be portraits, and this, of course, meant painting accurate likenesses. William Howe Downes noted Benson's ability to "combine the human interest of portraiture—an unconventional and intimate sort of portraiture—with an exquisitely complete decorative effect." In *Portrait of My Daughters*, Benson achieves this "decorative effect" by unifying figures and background. The trees and the flowing hair of Elisabeth and Sylvia echo each other, while the line of Eleanor's bent arm is continued by the bench ledge, which is parallel to the horizon.

In an era of rapid, sudden change, Benson's paintings offered a reassuring view of harmony and calm—"a holiday world," in Downes' words, "in which nothing ugly or harsh enters, but all the elements combine to produce an impression of the natural joy of living."

Oil on canvas, 26 × 36⅛ in. (66 × 91.8 cm). Worcester Art Museum, Worcester, Massachusetts

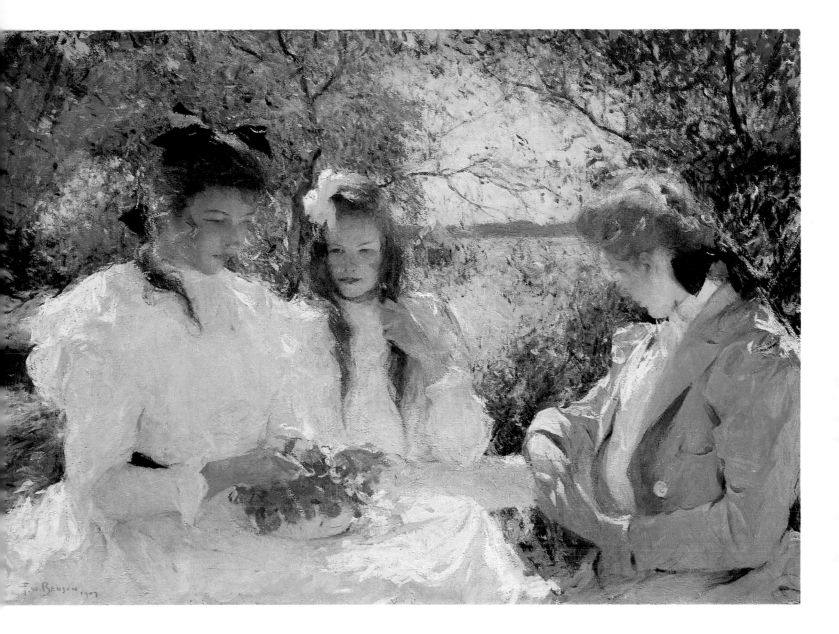

FRANK BENSON
1862–1951

The Silver Screen, 1921

*B*y 1920, Frank Benson had moved on from portraying young women reposing in softly lit interiors or dressed in white on windy hilltops. Summers in Maine were devoted to the watercolors, drawings, and etchings of birds, fish, and game for which he became most famous. Pictures of idle young women living in a trouble-free world had lost their appeal by the last years of World War I.

So it is surprising that in the early 1920s Benson produced a series of richly colored, large still lifes in oil that evoke that genteel, privileged world. Those young women do not appear in paintings such as *The Silver Screen*, but the accoutrements of their refined life do. The table is covered with a turquoise-gray fabric with a delicate Oriental pattern, and a sumptuous golden swath is draped over its edge. The yellows and oranges in this cloth are repeated in the bowl of fruit. A grand Chinese jar lends a balance and majesty to the composition, set against the screen that gives the painting its title. A small dish between the bowl and the jar underscores the delicate equilibrium of this asymmetrical, elegant arrangement, which enhances the beauty of each object.

Benson acknowledged the artfulness of his still lifes. "Design makes the picture," he said. "A picture is good or bad only as its composition is good or bad. You can't make a good still life simply by grouping a lot of objects, handsome in themselves. You must make a handsome arrangement, no matter what the objects are." Despite Benson's stress on compositional order, the innovations of French Impressionism are apparent in his work. The tabletop seems to tip forward, and the fabric at the right is cropped by the frame, giving the work frontal impact that departs from traditional still lifes. The asymmetrical composition reveals the influence of Japanese prints; so does the screen in the background, which limits the illusion of depth, and emphasizes the flat picture plane. While Benson's brushwork here is firmer than in outdoor figural works like *Portrait of My Daughters*, there is as great a variety of tones. Here his brushstrokes suggest the effect of light cast on the surface of the screen, and silvers and golds are invested with an opalescent luster. Yet these forms, like his figures, maintain their solidity, clearly silhouetted against the background.

The Silver Screen may be admired for the sheer skill with which Benson manages subtle distinctions of tone and eye-catching arrangements of objects. At the same time, the painting evokes the pleasures of aesthetic pursuits, such as the collecting of antiques and fine textiles—the enjoyment of beauty on the plane of daily experience.

Oil on canvas, 36¼ × 44 in. (92 × 111.7 cm). Museum of Fine Arts, Boston; A. Shuman Collection

JOSEPH RODEFER DECAMP
1858–1923

The Seamstress, 1916

By the turn of the century, many Boston artists, Joseph DeCamp among them, were following the fashion, established by Edmund Tarbell, of painting leisurely and graceful young women in spacious interiors. DeCamp, a close friend of Tarbell and Frank Benson, worked in a style informed by academicism as well as by Impressionism. He painted a number of colorful landscapes, but he is best known for firmly rendered figures in softly lit interiors.

Unlike his Boston colleagues, DeCamp was from Cincinnati, not New England, and (like other Cincinnati artists, including John Henry Twachtman) he trained in Munich rather than Paris. From 1878 to 1880, DeCamp studied at the Munich Royal Academy under Wilhelm von Diez, who advocated experimental work and instilled in DeCamp a long-lived respect for technique. While in Munich, and in Florence from 1880 to 1881, DeCamp was also a pupil of Frank Duveneck (originally from the Cincinnati area) who encouraged him to paint boldly.

By 1884 DeCamp had moved to Boston. He soon abandoned the dark tonalities and bravura manner of his student days for the smoother brushwork and brighter palette used by his contemporaries. DeCamp, Tarbell, and Benson represented the Boston contingent of the group called Ten American Painters.

DeCamp often lighted an interior by only a thin stream of light entering sideways through a window; in this way he showed the influence of the seventeenth-century Dutch artist Jan Vermeer, whom he emulated. However, in *The Seamstress* he challenges the Dutch convention, filling the scene with light from a large, central window and seating a figure directly in front of it. Instead of noting subtle gradations of light by means of soft grays and browns (the color scheme preferred by Boston figural artists of the era), DeCamp mixes white pigment with silvery and pastel shades. The effect recalls some of Whistler's decorative monochromatic portraits, which notably use white to create pale tones for both the figure and the background.

Contemporary critics praised *The Seamstress*. One of them wrote, "The Seamstress has a luminous silvery tonality," and another called it "melodious in tone and conscientious in execution." Indeed, the depiction of the seamstress is enhanced by the soft interplay of gold and silver tones. The lacy, light-struck surfaces of her dress glow amid a sheen of gold-lavender. The copper color of her hair is echoed in the polished table, on which her sewing tools gleam. The world outside the window is suggested by a mixture of lavender and gray-blue shades; gauzy white curtains offer a gentle transition between indoors and outdoors.

DeCamp's technique is varied and animated; his use of a thick impasto in some areas and smooth brushwork in others evidences his Munich training as well as his Impressionist sensitivity to the effects of light. As the critic Arthur Hoeber wrote, "None of the modern painters . . . is better equipped technically than is Joseph DeCamp . . . how at ease he is as far as the mere rendering of surfaces, textures and forms may be seen by a glance at any, even the least important, of his canvases."

Oil on canvas, 36½ × 28 in. (92.7 × 71.1 cm). The Corcoran Gallery of Art, Washington, D.C.; Museum Purchase

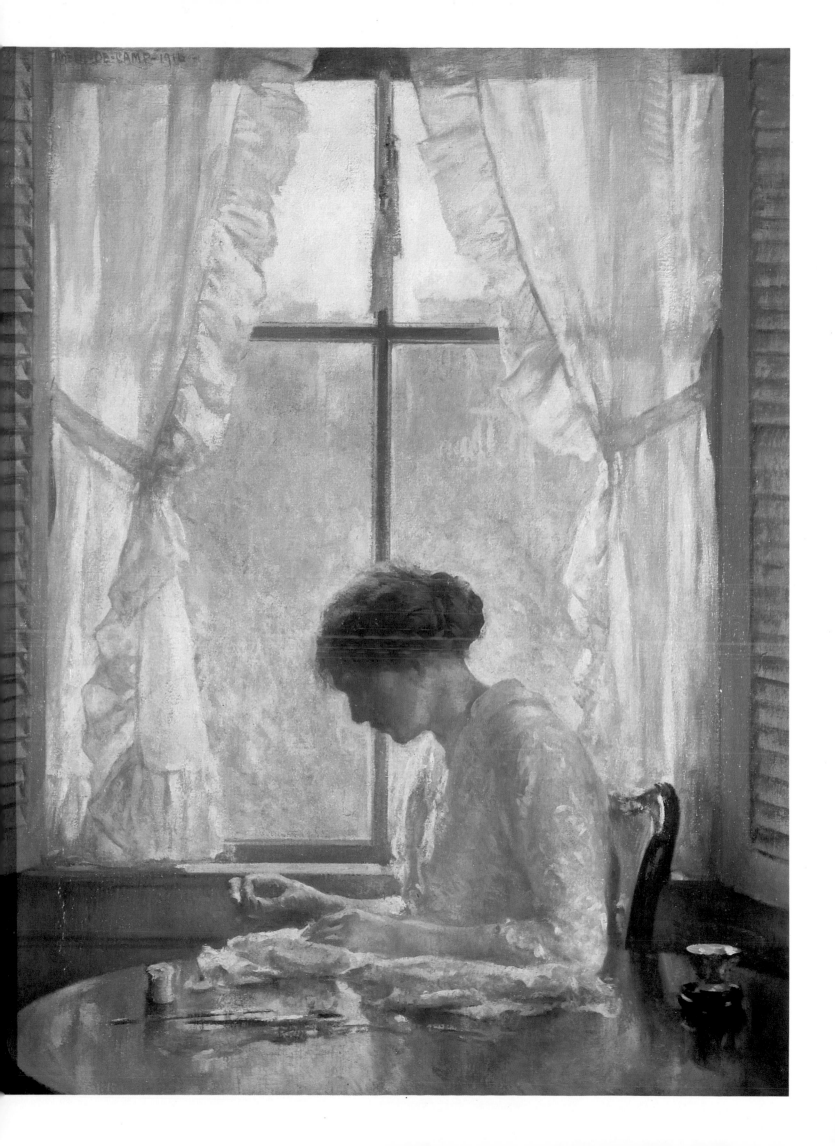

THOMAS DEWING
1851–1938

Brocard de Venise, ca. 1905

Throughout his twenty-one years as a member of the Ten American Painters group, from 1898 to 1919, Thomas Dewing was a resident of New York. However, his paintings of contemplative women in elegant interiors are more akin to those of the Boston members, Edmund Tarbell, Frank Benson, and Joseph DeCamp. Dewing created the least Impressionistic works of the Ten. For both indoor and outdoor scenes, he avoided the effects of brilliant sunlight, in favor of precisely drawn figures who hover in dimly lit rooms and misty landscapes.

Dewing spent much of his early career in Boston, working in a lithography shop and then studying under the artist-physician William Rimmer, who inspired an interest in draftsmanship, which would remain strong throughout his career. In 1878, after a period of study at the Académie Julian, in Paris, he returned and began teaching at the Boston Museum School; he was joined a year later by Tarbell, who would become the school's guiding force.

On moving to New York in 1880, Dewing began to paint precisely modeled, idealized figures clad in vaguely Grecian gowns and posed as in a frieze against schematic landscapes. These works displayed his academic skills and his awareness of the decorative manner of the English Pre-Raphaelites. His interest in Japanese art also emerged in the late 1880s.

Around the turn of the century, Dewing, like so many artists of the era, became interested in the seventeenth-century Dutch painter Jan Vermeer. In *Brocard de Venise* Dewing adopts Vermeer's compositional formulas. Figures are arranged in asymmetrical, diagonal positions, their poses strengthened by the placement of furniture. The two women share a single open space, yet each is physically and psychologically isolated. Playing a spinet, the woman in black is angled away from her companion; perhaps her music is strictly for her own enjoyment. Seemingly far away, the figure on the right is pensive, like so many of the women depicted in canvases of that era (for example, the figure in DeCamp's *The Seamstress*), except that she has no sewing or reading to occupy her attention. Instead, whatever is on her mind seems to hold her in a trance; perhaps her attention is engaged by otherworldly matters.

Even the room itself seems a world apart. A mist wafts through it, obscuring the brocaded wallpaper (which gives the work its title). Its swirling and twisting ribbons become intricately visible and blurred. Dewing's interest in tonal harmonies reflects the influence of Whistler, in whose London studio he had worked briefly in 1890. Indeed, the foreground figure in *Brocard de Venise* recalls Whistler's famous portrait of his mother.

The isolation of figures despite their physical proximity was also a feature of the paintings of Edgar Degas. But Dewing's works, unlike Degas's, do not suggest the detachment and alienation of a mechanized, commercialized age. Instead, his elegant, dreamy figures seem to inhabit a rarefied realm conducive to contemplation.

Oil on panel, 19⅜ × 25⅝ in. (49.2 × 65 cm). Washington University Gallery of Art, St. Louis; Gallery Purchase, Bixby Fund, 1906

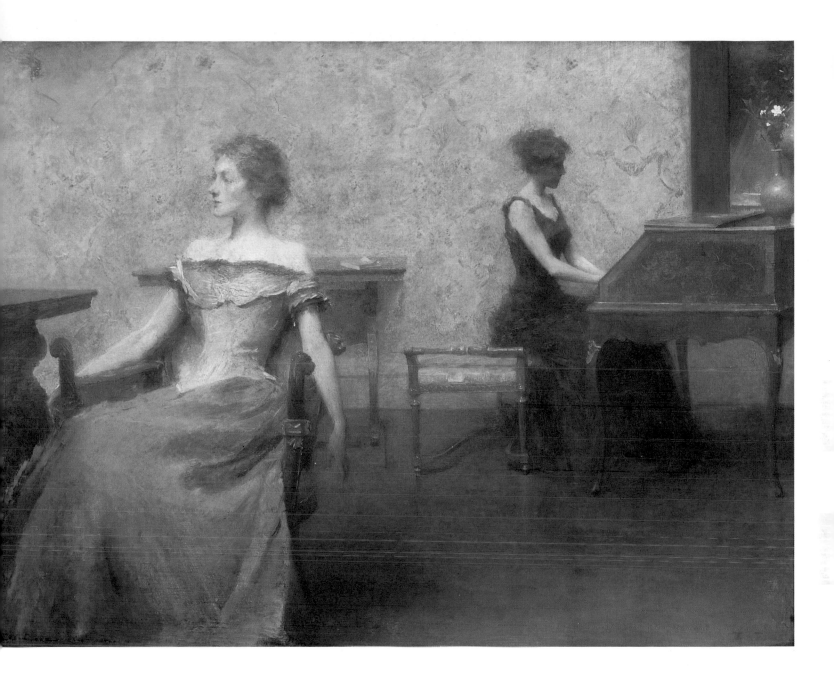

ROBERT REID
1862–1929

The White Parasol, ca. 1907

Robert Reid was the American Impressionist best known for combining a graceful decorative approach with spontaneous plein-air methods. This aesthetic yielded many softly vibrant canvases in which female figures are elegantly integrated into landscapes filled with flowers. By 1899, Reid had become so closely identified with this combination that a critic wrote, "Reid can apparently not see a girl without seeing a flower, nor a flower without seeing a girl."

The artist's predilection for the figural resulted from his many years of academic training. Born in Stockbridge, Massachusetts, Reid began his studies at the School of the Museum of Fine Arts in Boston. In 1885, he departed for Paris, where, like countless other artists of the era, he enrolled at the Académie Julian. In the late 1880s, he rendered melancholy images of peasant life. A more lyrical mood emerged in his paintings after his return home.

Reid settled in New York in 1889, and by the end of the next decade he was basing his mature style upon gentle color harmonies and unified designs. This direction had been spurred by his work on a number of murals for the 1893 World's Columbian Exposition, in Chicago. Adapting the principles of mural painting to the easel, he soon began to orient his imagery to the picture's flat surface. His Impressionist and decorative styles emerged simultaneously and in a synthesis that most other artists of the day did not achieve. Thomas Dewing, for instance, who similarly placed idealized figures in landscape settings, created general visions of the outdoors and avoided the real-world qualities of light and atmosphere that most Impressionists strived to capture. A member of the group known as the Ten American Painters, Reid represented both its stylistic extremes. He experimented, along with the more avant-garde artists in the group (such as Twachtman and Weir), to make his landscapes vivid and immediate, while he adhered to the academic tendencies of the more conservative members (such as Tarbell and DeCamp) in his representations of the human form.

The White Parasol exemplifies the refinement and gentility of Reid's art. His modernity may be seen in his insistence on maintaining the flatness of the picture's surface. Showing the opened parasol in a direct, frontal way, he emphasizes the two-dimensionality of the image. Figure and flowers seem to exist on one patterned plane: the dancing floral forms more surround than back up the figure. Rendered with short, assured strokes, the blossoms blend together, except for the bold tiger lilies, whose curling petals echo the arches of the parasol. The landscape has a screenlike, artificial effect, yet this is countered by the large bunch of fresh flowers in the woman's right arm. The viewer may well wonder how this woman, carrying a parasol, could have collected so many blooms while on a garden stroll; hardly robust in her white, high-collared dress, she almost appears to be the most delicate and ethereal blossom of them all.

Oil on canvas, 36 × 30 in. (91.4 × 76.2 cm). National Museum of American Art, Smithsonian Institution, Washington, D.C.

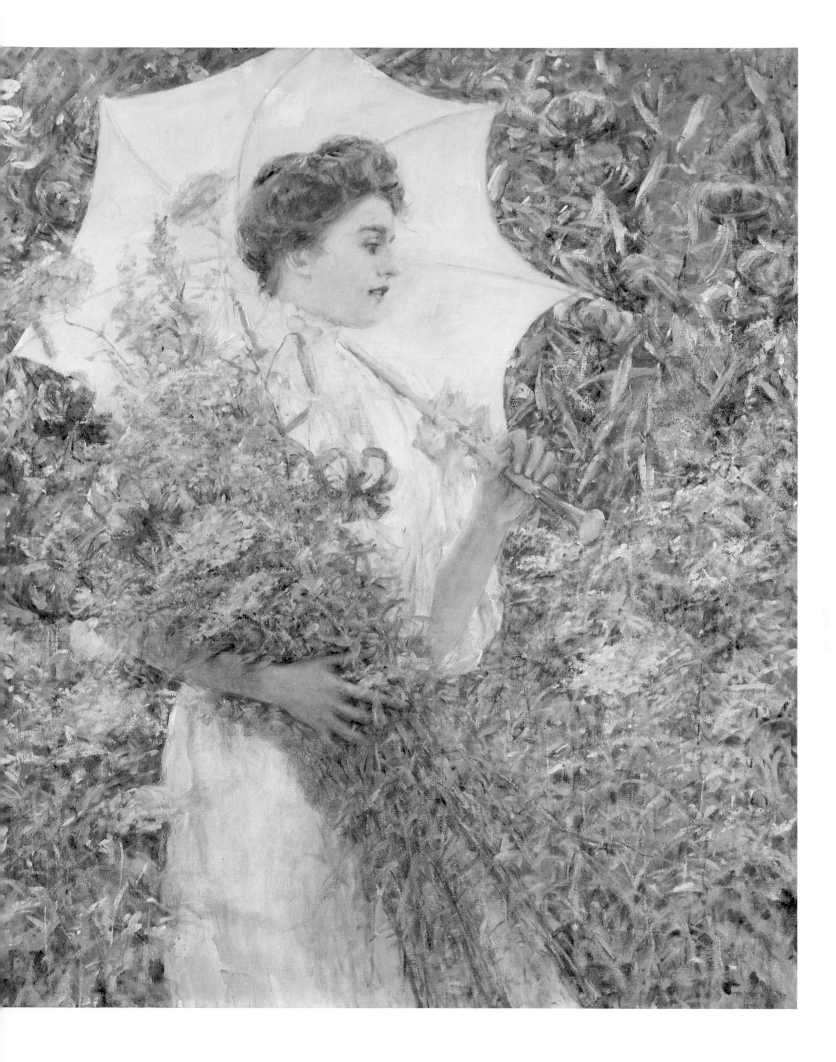

GEORGE HITCHCOCK
1850–1913

Spring Near Egmond, ca. 1900

In an era when the majority of American artists who traveled abroad congregated in Paris or painted in the French countryside, George Hitchcock, born into a prominent New England family, chose to settle in Holland. He discovered the fishing village of Egmond, located on the North Sea not far from Amsterdam, in 1883. Taken with its picturesque scenery and friendly villagers, Hitchcock made Egmond his home for almost twenty years. He drew other artists to the town, transforming it into an artists' colony. Some of them, like his American friend Gari Melchers, remained in Egmond for many years; others, such as John Singer Sargent and James McNeill Whistler, paid brief visits.

Hitchcock also attracted numerous art students to Egmond, many of whom, like their teacher, painted the fields of tulips surrounding the village. Hitchcock is the nineteenth-century painter most closely associated with the tulip fields of Holland. He painted flowers in a way that even the Dutch had not.

Hitchcock had concentrated on religious and anecdotal subjects in the 1880s; in the 1890s, he turned increasingly to scintillating landscapes, earning himself the sobriquet "the painter of sunlight." In a 1911 article on Hitchcock, James William Pattison wrote,

Mr. Hitchcock first secured conspicuous notice because of his very unusual pictures of the famous tulip fields in full blossom. The tulip country is flat and sandy and the beds of flowers are laid out in long strips, some ten and some twenty feet wide. There are little straight paths between these, and every long strip is cut in sections, each devoted to a specific color. It may be first a section all rose, then one pale bluish, next a gay yellow, then violet, all this spread out like rugs laid on a floor in straight rows, and beyond them a house or a group of houses veiled by the delicate spring foliage of young trees, and the dull red walls and red tile roofs contrasting with the brilliant flowers.

Spring Near Egmond exemplifies the refined, decorative Impressionist style that Hitchcock had evolved by the turn of the century. Viewed from a low vantage point, the landscape is crisply divided into bright blocks of lavender and yellow; it bursts with color, yet a geometric substructure organizes and contains the radiant display. Hitchcock's brushwork is free and direct but disciplined. Distinct, individual flowers are spaced evenly across the foreground; in more distant rows, they blend into bands of generously applied pigment.

Hitchcock wrote a number of articles about the customs and beauty of his adoptive land. He noted that while Holland is not the gray country that Dutch paintings often show it to be, it has "opalescent attributes" in shadowy conditions that are not abolished by bright sunlight. Hitchcock's ordered compositions, filled with brilliant, fresh color, express his vision of that country's simplicity and splendor both. Chase's paintings of his beloved Shinnecock come to mind, yet there was an important difference between the two artists' philosophies. Whereas Chase scorned "composed" pictures in favor of direct expression, Hitchcock stressed the importance of design in conveying the essence of a subject. "He seeks to develop a taste in the selection of a worthy motif," one of his students recalled, "and to direct your capacity towards perfecting the idea so that you may not be satisfied with a mere sketch. You must cease to make studies and begin to make pictures."

Oil on canvas, 16½ × 21½ in. (41.9 × 54.6 cm). Private Collection

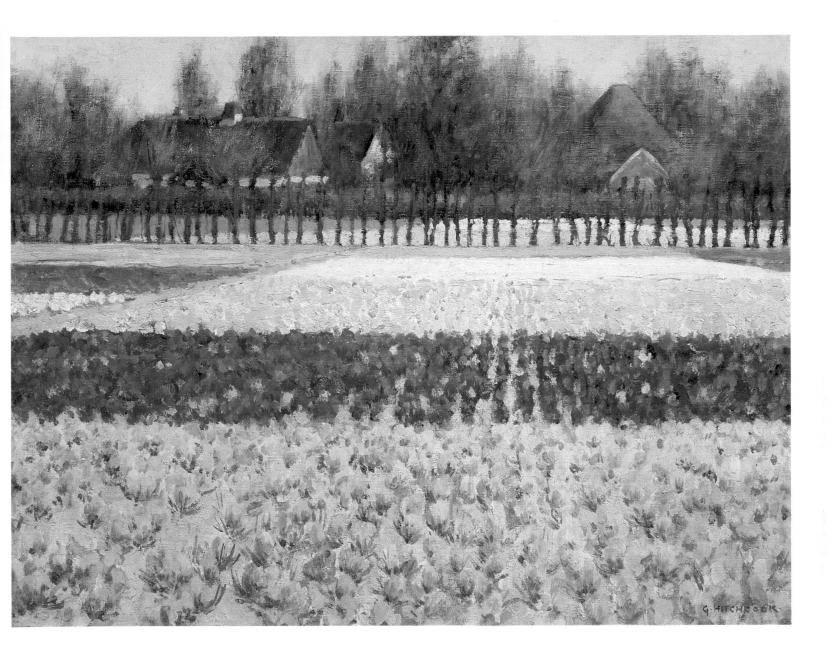

THEODORE EARL BUTLER
1860–1936

The Train, 1904

In 1886, Theodore Butler concluded his studies at the Art Students League in New York and departed for Paris, where he enrolled at the Académie Julian. He also studied in the atelier of Carolus-Duran, who had inspired John Singer Sargent's direct, dynamic style. While in Paris, Butler resumed a friendship with Theodore Robinson, whom he had met in New York and who introduced Butler to Giverny, where Butler would spend most of the rest of his life.

Butler was not among the group of American artists who converged on that Normandy village in the summer of 1887, but stories about Giverny soon reached him in Paris, and the following summer he accompanied Robinson there. After a brief visit to New York in the fall of 1888, Butler returned to Giverny and began to use the broken brushwork and the pastel tonalities of Claude Monet, Giverny's famous resident artist. It was the local landscape's beauty that first compelled Butler to stay, but he soon had another reason: Monet's stepdaughter Suzanne Hoschedé. Suzanne was the sister of Blanche, whose romantic relationship with another American painter, John Leslie Breck, had been ended by Monet. Butler's courtship was more successful; Monet allowed the two to marry, in July of 1892. Robinson painted their wedding procession, and another American artist, Philip Hale, served as the best man. The couple settled in a cottage in Giverny, and Suzanne bore two children over the next few years. In 1899, after a long illness, she died, and Butler returned home to Columbus, Ohio, accompanied by Suzanne's sister Marthe, and they married in 1901, on their return to Giverny. Butler's years in Giverny eventually spanned two generations of American artists who gathered there, and he served an important role in welcoming and helping these visitors.

Butler was close to his famous father-in-law, and he painted many of the same subjects. The younger artist first depicted railroad trains in 1893, twenty years after Monet. Like Monet, Butler was interested in painting the same subject over and over in a series, and from a mobile studio he worked on scenes of trains crossing through the Epte River Valley at different hours of the day. After the turn of the century, Butler's train series was enhanced and enlivened by avant-garde methods—the more subjective approach of the Post-Impressionists and the aggressiveness of the Fauves.

In *The Train*, a dark locomotive is submerged in the landscape; its presence is made known only by the smoke and steam billows that waft into the air and blend with lavender poplars. The train's smoke is echoed by the patches of snow, which Butler freely renders with large, blocky strokes. Like Monet, Butler captures fleeting effects, but he treats form in a more generalized way than the French master, and his brushwork creates a vortex that conveys not only the effect of the train's passage, setting the landscape vibrating, but also the artist's emotional response to this effect.

Oil on canvas, 22 1/4 × 28 1/2 in. (56.5 × 72.4 cm). Spanierman Gallery, New York

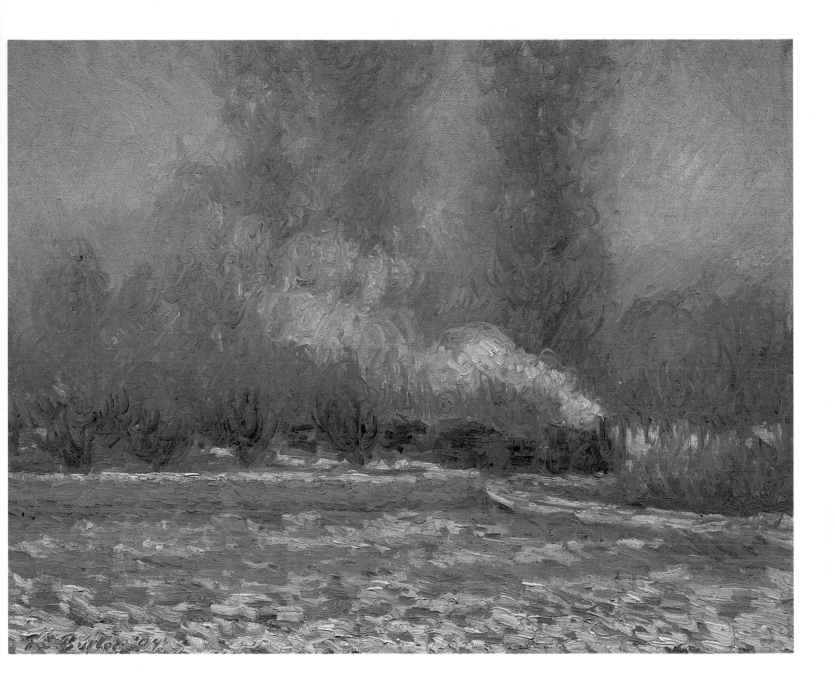

FREDERICK CARL FRIESEKE
1874–1939

Good Morning, ca. 1905

By the 1890s most of the original group of American artists who had made the pilgrimage to Giverny, France, including Theodore Robinson, Willard Metcalf, Theodore Wendel, and John Leslie Breck, had returned home. While a few, such as Lilla Cabot Perry and Theodore Butler, Monet's son-in-law, stayed on, a new generation of American artists established itself there after the turn of the century. The first generation had painted Monet-inspired landscapes; the second concentrated on figural painting distinguished by its decorative style and influenced by both Impressionism and Post-Impressionism. These artists included Louis Ritman, Richard Miller, Guy Rose, Lawton Parker, and their unofficial leader, Frederick Frieseke, whose Giverny residency was longest.

Born in Owosso, Michigan, Frieseke studied at the Art Institute of Chicago and the Art Students League, in New York, before leaving in 1898 for Paris. There he enrolled at the Académie Julian and also benefitted from the criticism of Whistler. By the time he settled in Giverny, in 1904, he had begun capturing the effects of sunlight and creating the harmonious compositions that would engage him for the rest of his career. Frieseke moved into the house where Robinson had lived, next door to Monet. But it was Renoir, not Monet, who was his mentor, as the use of bright colors in sumptuous patterns and his interest in painting the nude demonstrate.

Many of Frieseke's most scintillating works are set in his Giverny garden and portray his wife posed amid the flowers. While his wife was in charge of the garden, he decorated the interior of their home, painting the living room a bright yellow, the doors opening into the garden emerald green, and the kitchen a deep blue—scenes of which he then recorded on canvas.

In *Good Morning*, Mrs. Frieseke holds a parasol at the threshold of the door to the garden. Her pink-and-white striped gown, seen against the strong outside light, contrasts vividly with the greens and yellows that seem to spread the sun's warmth to the door and interior walls. The painting demonstrates Frieseke's ability to capture a variety of natural light effects. As he told a *New York Times* interviewer in 1914: "I do not like the usual studio light—it is so artificial. I pose my model in a naturally lighted room in an ordinary house. There is nothing like a long, faithful study of nature to lead one away from the artificial."

The artist has also conceived of the picture decoratively: he uses a frame-within-a-frame scheme that he favored for many of his Giverny canvases. The frame of the doorway reinforces the viewer's sense that a picture has been made of the woman and the garden; the compression of space enhances this. *Good Morning* conveys the artist's felicitous existence, his delight in the beautiful surroundings that he and his wife created in Giverny.

Oil on canvas, 32 × 26 in. (81.3 × 66 cm). The Butler Institute of American Art, Youngstown, Ohio

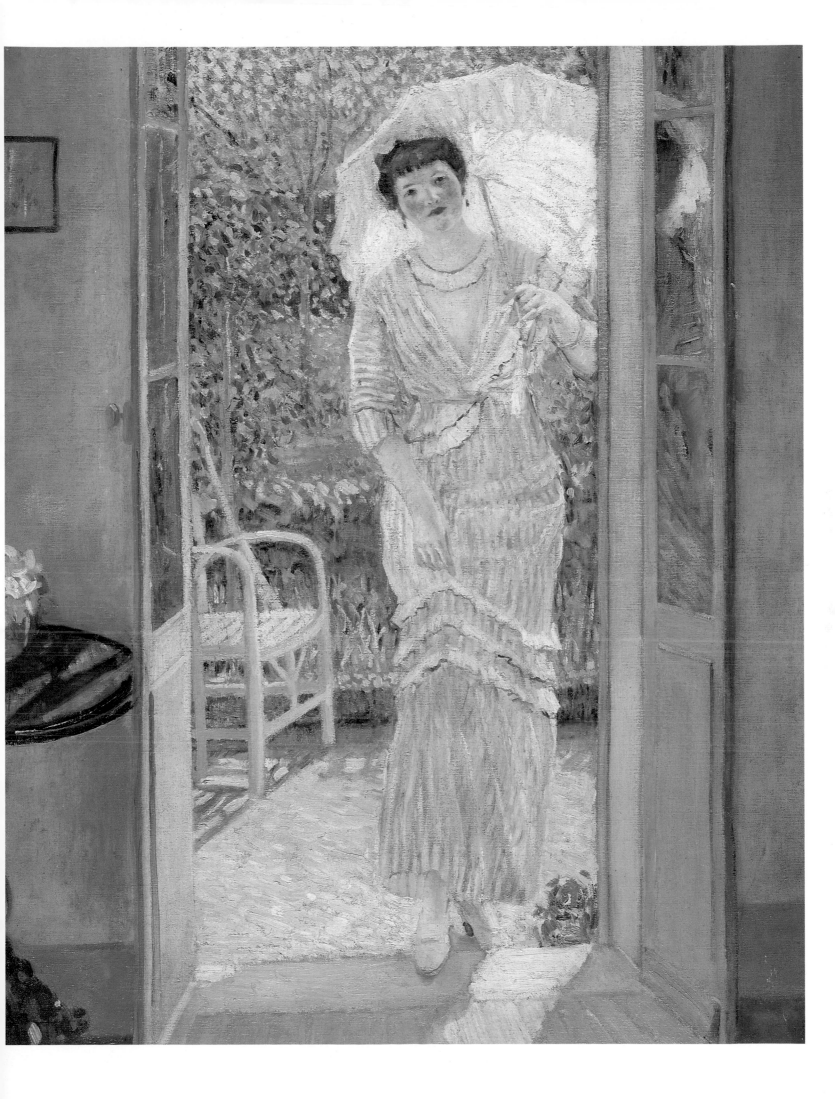

FREDERICK CARL FRIESEKE
1874–1939

The Bathers, ca. 1914

Although the nude throughout the history of art had been a subject of major importance for artists, especially academic painters, it was not often taken up by the American Impressionists. Frederick Frieseke, one of the few to address the subject, admitted that there were taboos against the nude in the United States, and he partly attributed his long residency abroad to the acceptance of the nude in France. He told the *New York Times* in 1914:

I stay on here because I am more free and there are not the Puritanical restrictions which prevail in America. . . . As there are so few conventionalities in France, an artist can paint what he wishes. I can paint a nude in my garden or down by the fish pond and not be run out of town.

The longstanding tradition of portraying female nudes as bathers was practiced by two of the great masters that Frieseke especially admired: Botticelli and Titian. Frieseke's *The Bathers* combines the grace of Botticelli's nude bathers with the earthiness of Titian's. But in depicting his wife—on the left, removing her blouse—and another figure—on the right, about to enter the water—the artist shows a greater debt to the French Impressionists.

The interest in depicting realistic rather than idealized nudes begins with Edouard Manet's scandalous *Déjeuner sur l'herbe*, of 1863 (in the Musée d'Orsay, Paris), in which the artist protested against the falsity of Salon standards for the nude. During the 1880s, the uproar caused by this painting had subsided, and artists such as Renoir (whom Frieseke greatly respected) returned to idealization while maintaining modern techniques. While Frieseke does not evoke the great Neoclassicist painter Ingres to the extent that Renoir did, his purpose is clearly to present the nude as an opportunity for the contemplation of naturalistic beauty.

The Bathers demonstrates Frieseke's ability to capture specific qualities of sunlight and its impact on figures both nude and clothed. Through the foliage light gently plays on the water and glints amid the shadows. Gray and blue tones resonate by being made apparent in both the skin of the nude and in the patterned clothing. Thanks to Frieseke's years of academic training, the figures are skillfully modeled. But there are also decorative aspects to their integration into the work, for they contribute to a circle implied at the center of the canvas. Moreover, rendered with the same tones as the rest of the image, they recall the flatness and compositional arrangement of ancient bas-relief sculptures and friezes—another of Frieseke's interests. Figures and natural forms become unified by patterning; we have the sense of a self-contained private world. Like the French Intimists Edouard Vuillard and Pierre Bonnard, Frieseke depicts an outdoor scene that has a comfortable domestic flavor.

Even though Frieseke stated in 1914 that in America paintings of the nude were normally censured, his were received with great acclaim at the 1915 Panama–Pacific Exposition, in San Francisco. His graceful and refined figures undoubtedly relieved, rather than unsettled, a public that had been exposed to the revolutionary canvases of Picasso and Matisse at the Armory Show, only two years before.

Oil on canvas, 38 1/8 × 52 in. (96.8 × 132 cm). Collection of Mr. and Mrs. Hugh Halff, Jr.

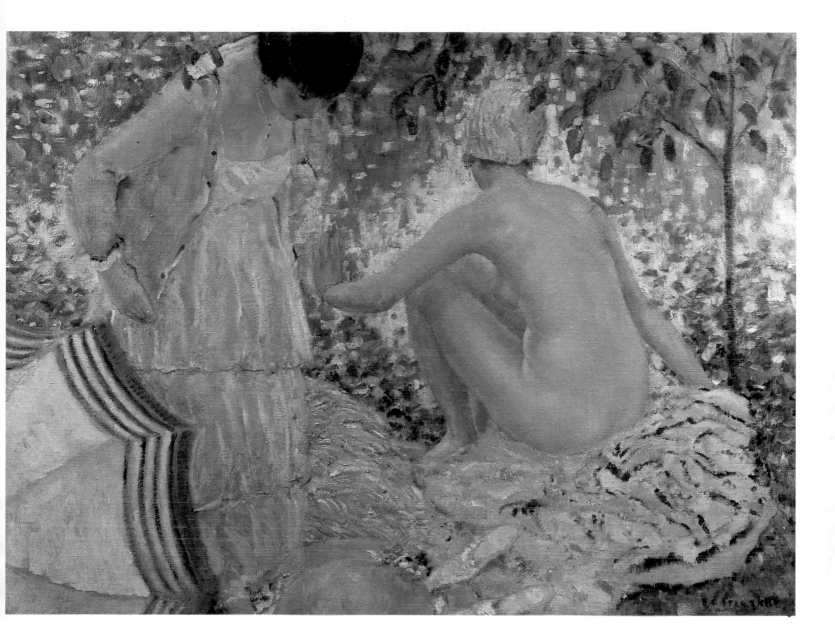

RICHARD EMIL MILLER
1875–1943

Reverie, ca. 1910

Richard Miller's career paralleled that of his friend Frederick Frieseke. Both artists were from the Midwest, and both departed for Paris around the turn of the century, after training in America. Frieseke had settled in Giverny, France, by 1904; Miller arrived shortly thereafter. The two became the best known of the second generation of American artists there. Miller remained until 1916, when he returned and settled in Provincetown, Massachusetts, becoming the dean of its artists' colony.

Like Frieseke, Miller derived inspiration from the Impressionists and the Post-Impressionists, and he wove his figures into rich and colorful decorative schemes, making them design elements within compositions filled with patterned forms. Yet Miller retained an academic bent, using a crisp, tight line to define figures and placing them in landscapes or interiors which remain secondary, supporting and supplementing rather than dominating them. The woman in *Reverie*, for instance, is rendered with the same lavenders and blues as the background, but she is obviously the most significant presence in the canvas. She rests her head on her arm in a traditional pose that, together with the pale pastel tones of the work as a whole, suggests an easy life, with time for daydreaming.

The first generation of artists in Giverny were primarily landscape painters; some, such as Theodore Robinson, also depicted figures, generally peasants. In contrast, the second generation, after the turn of the century, portrayed more refined women wearing fancy gowns and often self-absorbed at dressing tables in rich boudoirs. Miller and Frieseke are like the Boston Impressionists Edmund Tarbell and Frank Benson in this respect.

Yet Miller's paintings are executed with full chromatic range and lack the austerity of the Boston canvases, with their silvery and brownish Vermeer-inspired palettes. Miller claimed to be interested only in the formal properties of art. He stated to Wallace Thompson, the Paris correspondent for the *Fine Arts Journal*, that "art's mission is not literary, the telling of a story, but decorative, the conveying of a pleasant optical sensation."

But *Reverie* does speak of more than composition, color, and technique. In adorning the setting with a dressing table on which is laid a mirror, a jewel box, and a candle, the artist subtly suggests the theme of vanitas, of the transience of all worldly things, such as beautiful clothes: the figure is dressed, for her contemplative moment, in a flowing, diaphanous violet gown, its skirt hemmed in purple and its bodice edged with lace. Increasing the sensory appeal of the scene, Miller brings the vibrancy and warmth of the outdoors into the space, as French windows open onto a sunny landscape. Venetian blinds diffuse the light, multiplying the array of softly glowing colors in the woman's skirt and creating reflections in the floor. Resonating throughout the image, the light underscores the evanescence of life and its pleasures.

Oil on canvas, 45 × 58 in. (114.3 × 147.3 cm). The St. Louis Art Museum; Museum Purchase

LOUIS RITMAN
1889–1963

Girl in a Garden, ca. 1916

Louis Ritman first visited Giverny in 1911. Over the next two decades, he would become an important member of the second generation of American artists who congregated there. Whereas the first generation, who came to Giverny in the late 1880s, were primarily landscapists in the style of Monet, the artists who worked there after the turn of the century concentrated on the figure and adopted the decorative strategies of the Post-Impressionists, such as Edouard Vuillard and Pierre Bonnard.

Born in Russia, Ritman emigrated with his family to Chicago in 1903. He studied in Chicago, at the Art Institute; in New York, under William Merritt Chase; and in Paris, at the Ecole des Beaux-Arts. Frederick Frieseke, whose student days at the Chicago Art Institute overlapped his, may have introduced Ritman to Giverny. Then dominant among the Americans in that Normandy village, Frieseke is thought to have given further training to Ritman. The two artists' works do share many stylistic characteristics. Both created images of women relaxing in boudoirs or vibrant floral landscapes, but Ritman's handling of paint and predilection for ordered compositions distinguish his work from Frieseke's. With delicate brushstrokes, he treated the canvas surface as a flat plane, enriching it with pulsating dots of color. In 1919, a critic for *International Studio* concluded, "Ritman is far defter of touch, more exquisite in pattern, more richly varied and sensitive of surface than Frieseke."

Girl in a Garden demonstrates Ritman's ability to create an image that, while highly structured, seems natural. A freely growing garden shaded by trees abuts a house nearly swallowed up by climbing vines; only the shuttered windows denote the building amid the greenery. Indeed, foreground and background blend together, as the garden is uniformly animated by touches of yellow, white, blue, and orange, and the shimmering foliage in the center joins with that of the ivy on the house. The girl of the title is almost submerged in the rich pattern; it is her parasol that signals her presence in the space.

The landscape is generalized and abstracted, yet Ritman maintains control over the composition by the use of the windows and the pathways, which are almost like breathing spaces. Unlike Joseph Raphael, who painted his garden in Belgium around the same time, Ritman did not apply his pigment thickly and aggressively. Instead, with controlled and rhythmic brushstrokes, he reveals his delight in refined, restrained compositions.

Ritman eventually returned to live in Chicago, in 1930, but during his years in France, he kept in touch with Chicago's art community. In 1923, the *Chicago Art Institute Newsletter* hailed him as a "painter's painter . . . an exquisite weaver of patterns, a man to whom pigment seems a natural medium."

Oil on canvas, 36 × 36 in. (91.4 × 91.4 cm). Private Collection

PHILIP LESLIE HALE
1865-1931

A Walk Through the Fields, ca. 1895

In the 1890s, the Boston painter Philip Leslie
Hale was the most radical American
Impressionist; but after the turn of the century, not
only as a painter but also as a writer and teacher, Hale
was Boston's leading exponent of conservatism and of
learning from the Old Masters.

The son of Edward Everett Hale, the Unitarian
minister, orator, and novelist, Philip Hale inherited
his father's intellectual powers. He applied to
Harvard, at his father's insistence, but in 1883 he
enrolled in the Boston Museum School. After his
training there he went to New York's Art Students
League, where he was taught by J. Alden Weir.
Finally, in Paris, he was a pupil at the Académie
Julian and the Ecole des Beaux-Arts. His dark,
realistic early works show his admiration for Spanish
Baroque painters, particularly Velázquez; indeed, in
1890, he went to Spain to see their masterworks
firsthand. Hale divided the next three years between
New England and France, including Giverny, where
his friend Theodore Butler and other American artists
had gathered, near Monet. During this time, Hale was
influenced by Post-Impressionism as well as
Impressionism, and his works from this period differ
sharply from those he created just a short time earlier.

It was in the summer of 1891, while Hale was
visiting an aunt in Matunuck, Rhode Island, that he
made his adventurous experiments in Impressionism.
His canvases from subsequent decades reveal his
interest in the impact of sunlight on figures and
landscapes. In this he went further than most of
his peers, who remained reluctant to abandon the
academic method of defining the figure in terms of its
volume. Frank Benson, for example, in his paintings
of his family outdoors, created exact likenesses with
clear contours, carefully distinguishing figures from
the space surrounding them. In contrast, in *A Walk
Through the Fields*, the figure's gown is saturated with
the same brilliant hues as the landscape is, and under
the intensity of the sunlight, she appears to dissolve,
becoming almost an apparition. (Hale dressed his
Matunuck models in diaphanous costumes to allow
this sunlight effect as much play as possible.) Only the
dark fringe of her parasol and the blue bands at her
waist and neck anchor her in the field. She seems as
ethereal as the delicate flowers that curve behind her.

By employing a high horizon which serves to tilt
the field upward Hale adds to the vivacity of the
vision: rather than using a perspectival scheme that
would draw the viewer into the pictorial space, he
creates a flat image that one reads immediately. The
painting thus appears as a glimpse, a quick impression
of a scene that is almost too brilliant for the viewer's
sustained gaze. When Hale's works were shown in
1899 at the Durand-Ruel Galleries in New York,
viewers were indeed stunned, but not in a very
positive sense, and critics found Hale's color and
dissolution of form disconcerting.

In the decade that followed, Hale gradually turned
toward his more conservative reliance on firm
draftsmanship and tight modeling. One reason for this
change may have been his role as an instructor of
antique drawing at the Boston Museum School (one of
his students, Lilian Westcott, became his wife). Hale
never delved into progressive styles again, but devoted
himself not only to the teaching of academic methods
and ideas but also to critical writing.

Oil on canvas, 25 ½ × 31 in. (64.8 × 78.7 cm). Private
Collection

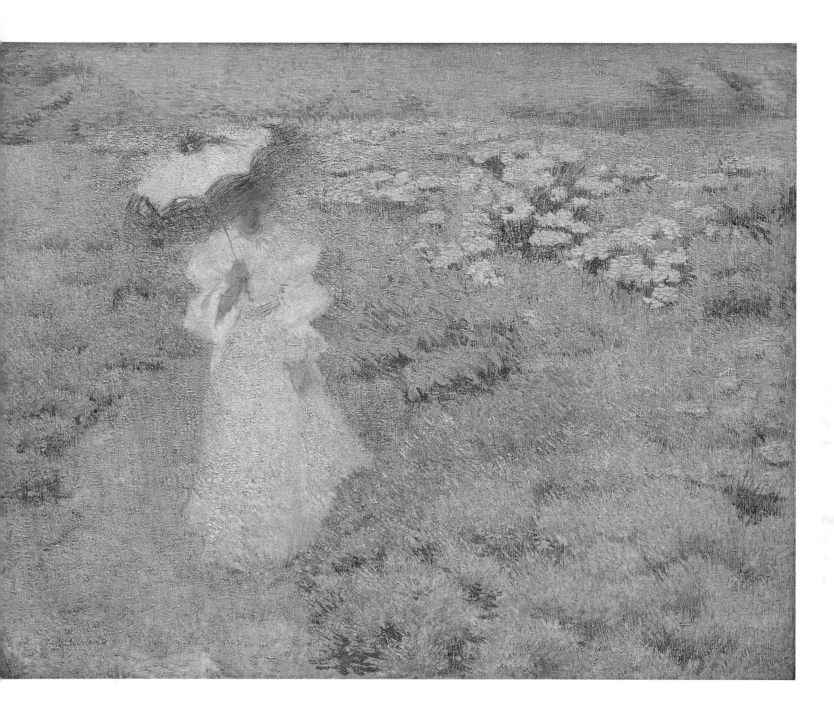

LILIAN WESTCOTT HALE
1881–1963

An Old Cherry Tree, ca. 1930

Lilian Westcott Hale worked for most of her career in Boston, where she was acclaimed for her technical skills, which she applied to meticulous drawings in charcoal and silverpoint and to harmoniously colored, gracefully composed paintings. Raised in Hartford, Connecticut, Lilian Westcott spent a summer, perhaps in 1897, at William Merritt Chase's art school, in the hills of Shinnecock, Long Island. In 1899, she enrolled at the Boston Museum School on a scholarship. Because she had already attained a high level of draftsmanship, she was allowed to skip the introductory courses and enroll in the painting class taught by Edmund Tarbell. While visiting a cousin in Hartford in 1900, she met Philip Hale, a drawing instructor at the museum school, and the two were married the following year by Hale's father, Rev. Edward Everett Hale.

At the time of their marriage, Philip Hale was still exploring the radical Impressionism he had formulated during the previous decade; but by 1910 he had turned to careful drawing, idealized figures in classical dress, and perspectival schemes—encouraged, no doubt, by his wife, who had proved herself competent in these traditional areas. She, in turn, was probably encouraged by him to adopt the heightened colors he preferred. Around 1910, Lilian Hale created a number of vibrant pictures of women influenced by the Art Nouveau style, employing fluid, curving lines and interlocking shapes. Her even brushwork, composed of long, thin, vertical strokes similar to her husband's, creates a gauzy filter through which her images emerge.

Hale continued to use this technique in landscapes even into the 1930s. In *An Old Cherry Tree*, the linear pattern of Art Nouveau and aspects of Oriental art are apparent. The landscape is treated as a flat screen, its surface accentuated by vertical forms that extend across the picture plane. Treated in a range of pastel shades—pale pink, green, and yellow—the hazy background creates an unobtrusive backdrop. Delicate perpendicular brushstrokes and vague vertical forms in the distance contribute to the screenlike effect and to the harmony of the design.

The dark, bare-limbed cherry tree in the foreground, delineated with the sensitive, adept draftsmanship for which Hale was praised, is the work's strongest motif. Silhouetted against the glowing shades of the rest of the work, this elegant and sinuous form seems an emblem of the enduring beauty, the grace and refinement, of natural forms. John Henry Twachtman depicts a similar subject but the opposite attitude in his *Wild Cherry Tree*, from around 1901. Twachtman treats his tree spontaneously, using it to create the glimpsing of a moment; Hale composes a still landscape, suspended in time. Hale's *An Old Cherry Tree* conjures a spiritual realm, as if through the gate in the foreground one would enter a mystical kingdom. Many artists in Boston after the turn of the century created refined and tranquil images, untouched by the concerns of modern life. However, most of them focused on the human figure. Hale was one of the few to express this theme in a landscape.

Oil on canvas, 30 × 25 in. (76.2 × 63.5 cm). National Academy of Design, New York City

JOSEPH RAPHAEL
1869–1950

Rhododendron Field, 1915

A native of San Francisco, Joseph Raphael was one of the first and best of the Impressionist painters to emerge from the West Coast. He received his initial training in his native city from 1893 to 1897 at the Mark Hopkins Institute of Art, where he was a student of Arthur Mathews, the school's director and founder. An influential painter in the Bay Area, Mathews originated the California Decorative Style, a regional version of Art Nouveau. Though French Impressionist works were on view in the region from the mid-1890s, Mathews' aesthetic dominated northern Californian art at the turn of the century. Thus, on his departure for Europe in 1903, Raphael had had minimal contact with Impressionism, and his interest in it was roused only after he had been abroad for a number of years.

On his arrival in Paris, he enrolled at the Ecole des Beaux-Arts and at the Académie Julian. That summer, he visited Laren, a picturesque artists' colony southeast of Amsterdam. For the next nine years, he divided his time between Paris and Laren, but his art was influenced by Dutch painting—the low-key, tonalist style of the Hague School. Gradually, Raphael started to use a more colorful palette for plein-air landscapes. In 1912, after getting married and moving to Uccle, a suburb of Brussels, Raphael began to paint forceful, vivid floral landscapes. Although American Impressionists such as John Henry Twachtman and George Hitchcock had painted such landscapes, Raphael's were distinctive. Unlike Twachtman, who was concerned with subtle effects of light and atmosphere, Raphael combined staccato brushwork with an aggressive physicality reminiscent of Vincent van Gogh's to arrive at an expressive, semi-abstract style. In many of his canvases, individual flowers are subsumed in turbulent masses of vibrant color and varied shapes that explode from the frame. His scenes therefore differ also from Hitchcock's tidy tulip fields, painted around fifteen years earlier.

In 1915, Raphael moved to a small house on the edge of Uccle that was surrounded by an abundant garden. Its floral profusion is probably the subject of *Rhododendron Field*. It is as much the artist's subjective response to the scene that is expressed as the spectacle itself; he shows the cottage at the left as engulfed by the flowering shrubs, and the high horizon tips the plane of the flowery carpet forward, so that the blossoms seem to cascade into the viewer's space. Raphael's art reflects the evolution of Impressionism, early in this century, from a means of capturing the transitory effects of light and atmosphere to a personal means of conveying emotional reactions to subjects.

The thickly painted, vigorous landscapes that Raphael sent home to California for exhibition had a strong impact on the development of Impressionism there. The San Francisco artist William Clapp acknowledged Raphael's significance in 1917: "Joe was practically idolized by the younger generation of painters, an idolatry that continued until the ultra-modern movements gradually replaced Impressionism." Visiting California in 1939, Raphael was prevented from returning to Belgium by the outbreak of the Second World War, and so he remained there for the rest of his life.

Oil on canvas, 30 × 40 in. (76.2 × 101.6 cm). The Oakland Museum, California; Gift of Dr. William S. Porter

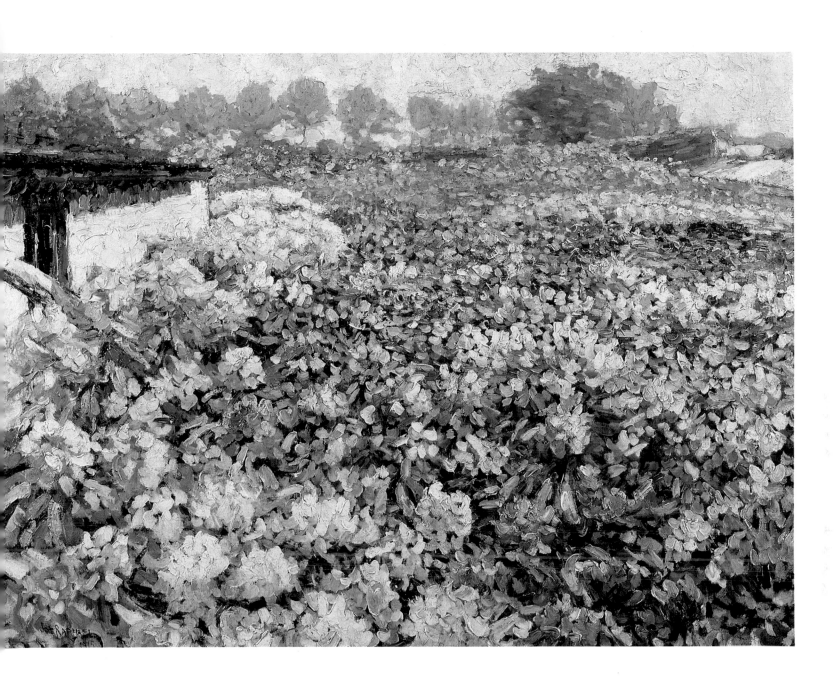

JANE PETERSON
1876–1965

Vedder's Fountain, Tiffany's Garden, ca. 1910

Early in her career, Illinois-born Jane Peterson sought instruction from a number of the best-known artists of her day. Arthur Wesley Dow, at Brooklyn's Pratt Institute, encouraged her to take a decorative approach, instilling an appreciation for the compositional principles of Japanese prints and the curvilinear outlines of Art Nouveau. These had lasting influences upon her art.

Peterson continued her studies with the academic painter Frank Vincent Dumond, at the Art Students League, in New York; with the English portraitist Frank Brangwyn, in London; and with Jacques-Emile Blanche and Claudio Castelucho, in Paris. Living around the corner, Gertrude Stein invited Peterson to a number of her famous Saturday evenings, where the company included Picasso and Matisse. Despite her contact with this milieu, Peterson was unaffected by the revolutions in pictorial space and form that radicals like the Cubists were exploring.

Peterson was most influenced by Joaquin Sorolla y Bastida, a well-known painter in Madrid, under whose tutelage, in 1909, she abandoned dark tonalities and a traditional modeling of forms. She adopted a spontaneous method of applying paint, a palette of sumptuous colors, and a direct approach. Peterson later wrote of her mentor, "I have watched him paint, listened to his words of wisdom, accepted his hospitality, adored his devotion to his family, and am a humble worshiper at his shrine."

In 1910 Peterson accompanied Sorolla to the United States when he was commissioned by Louis Comfort Tiffany to paint his portrait. The grounds of Laurelton Hall, Tiffany's estate in Oyster Bay, Long Island, were filled with magnificent flower gardens and a water-lily pond, perhaps inspired by Claude Monet's. A fountain designed by Elihu Vedder, an artist who spent most of his career in Italy, where he was inspired by decorative and classical styles, was placed in the landscape to spill water slowly into the pond. In *Vedder's Fountain, Tiffany's Garden*, Peterson's varied brush handling reveals her debt to Sorolla. The sunlit landscape is treated with vigorous dabs of color that lend it a tapestry-like richness. The quiet surface of the pond is rendered in long, smooth brushstrokes.

The artist conveys the harmonious coexistence of natural and man-made forms on Tiffany's property. The classical figures atop Vedder's fountain emerge from a shadowed space in the greenery that has a sanctuary-like appearance. The Tiffany home seems to peer from behind the dense foliage at the crest of the hill. A high horizon line flattens the pictorial scheme, and so the lush gardens seem to surge forward. The placid pond gives restraint and balance to the composition.

Later in her career, Peterson continued to travel and paint; in 1916, she joined Tiffany on a transcontinental painting expedition in his private railway car. She led a life of freedom and adventure seldom matched by the women artists of her day.

Oil on canvas, 40 × 30 in. (101.6 × 76.2 cm). Spanierman Gallery, New York

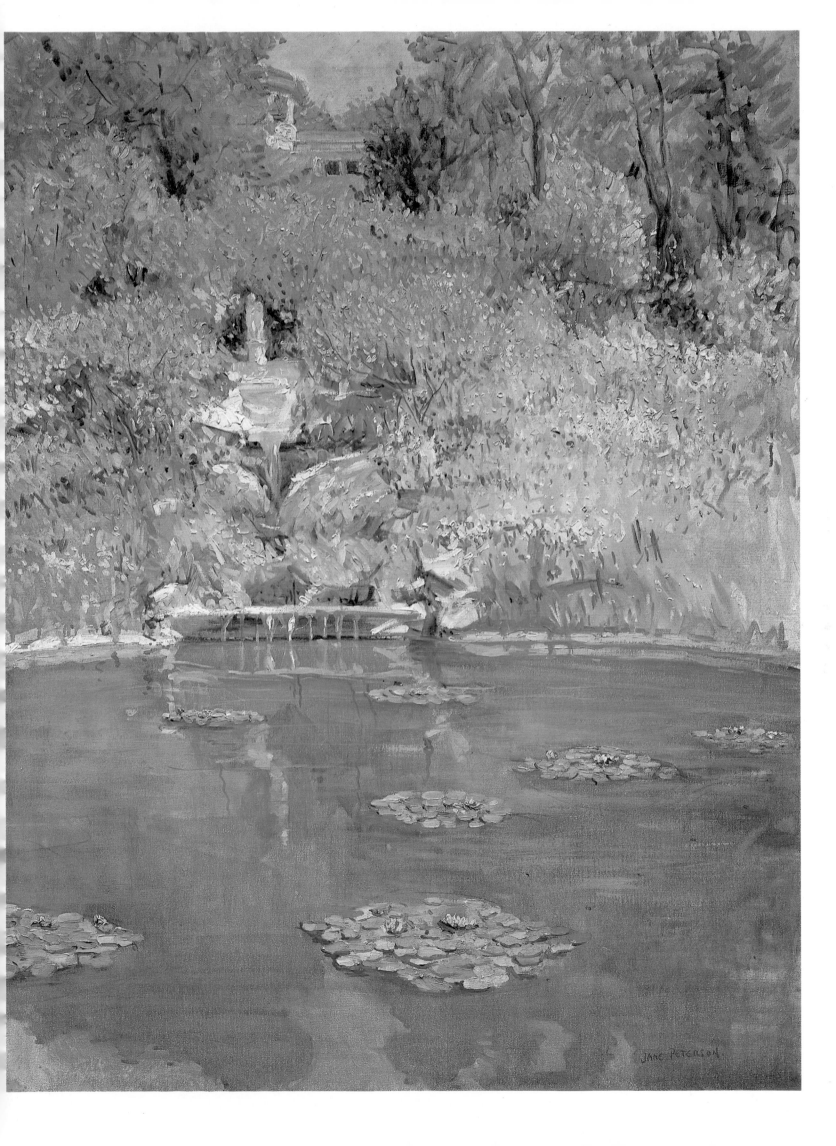

MAURICE PRENDERGAST
1859–1924

South Boston Pier, 1896

Maurice Prendergast is best known as a Post-Impressionist who synthesized a number of modern styles. Indebted especially to Paul Cézanne's emphasis upon pictorial structure, Prendergast's style synthesis was gradually formulated, and in the 1890s, the artist was still working in a more traditional Impressionist vein. His work of that decade was created mostly in watercolor. It was a medium well suited to an artist attuned to the brisk, free, and fashionable spirit of the Belle Epoque.

Born in Newfoundland, Prendergast was raised in Boston, and his early interest in urban subjects may have been fostered by the pictures painted by Childe Hassam in the late 1880s. In Paris from 1891 to 1895, Prendergast studied at the Académies Julian and Colarossi, but, like Hassam, he also studied life on the Paris boulevards. Executing small oil studies and drawings of the well-dressed women strolling by, Prendergast worked incessantly, filling many sketchbooks. Countless American artists were in Paris in the 1890s, but none were as alert as Prendergast was to the new art of the day. Influenced by James A.M. Whistler and the French Impressionists, he was also impressed by the work of Henri de Toulouse-Lautrec and that of the Nabi group, led by Pierre Bonnard and Edouard Vuillard. An interest in the flowing lines of Art Nouveau and in the expressiveness of color and form grew alongside a concern for light and atmosphere.

On his return to Boston, Prendergast, working in a fluid, decorative manner, continued to depict places that drew stylish throngs. One locale that appealed to him was a new promenade in South Boston where a spiraling pier connected two sections of the city. *South Boston Pier* is animated by swinging skirts of young women and young girls and by the exaggerated curve of the bridge. The flow of the females, who have their backs to us, pulls us into the scene; this movement is subtly countered by the males, all wearing yellow hats, as they come toward us. This juxtaposition seems to suggest tensions between the sexes, heightening the sense of a city alive with the new choices and conflicts of modernity. Moreover, Prendergast represents men, women, and children, but not families. This is a new social order.

Prendergast's technique enhances the vision. Strokes of color, applied with a light, energetic touch, suggest calligraphy as well as the rhythm of Art Nouveau. Flowery hats, skirts, and parasols are simply gestures made with watery pigment that, in drying, yields a variety of color effects. Yet the painting of the pier's railing, the lampposts along it, and the city in the distance are realistic, and the scene has a clear spatial progression. In the years to come, Prendergast would gradually integrate figures and landscapes into tapestrylike compositions that put the spatial levels of a picture on a single plane. (This was a modernist preoccupation—exploring the elements of pictorial representation—that showed Prendergast to be the most advanced member of the group known as the Eight.) His early scenes of Boston and turn-of-the-century watercolors of New York are still among the freshest of his works.

Watercolor and pencil on paper, 18 1/8 × 13 5/16 in. (46.1 × 35.4 cm). Smith College Museum of Art, Northampton, Massachusetts; Charles B. Hoyt Fund Purchase, 1950

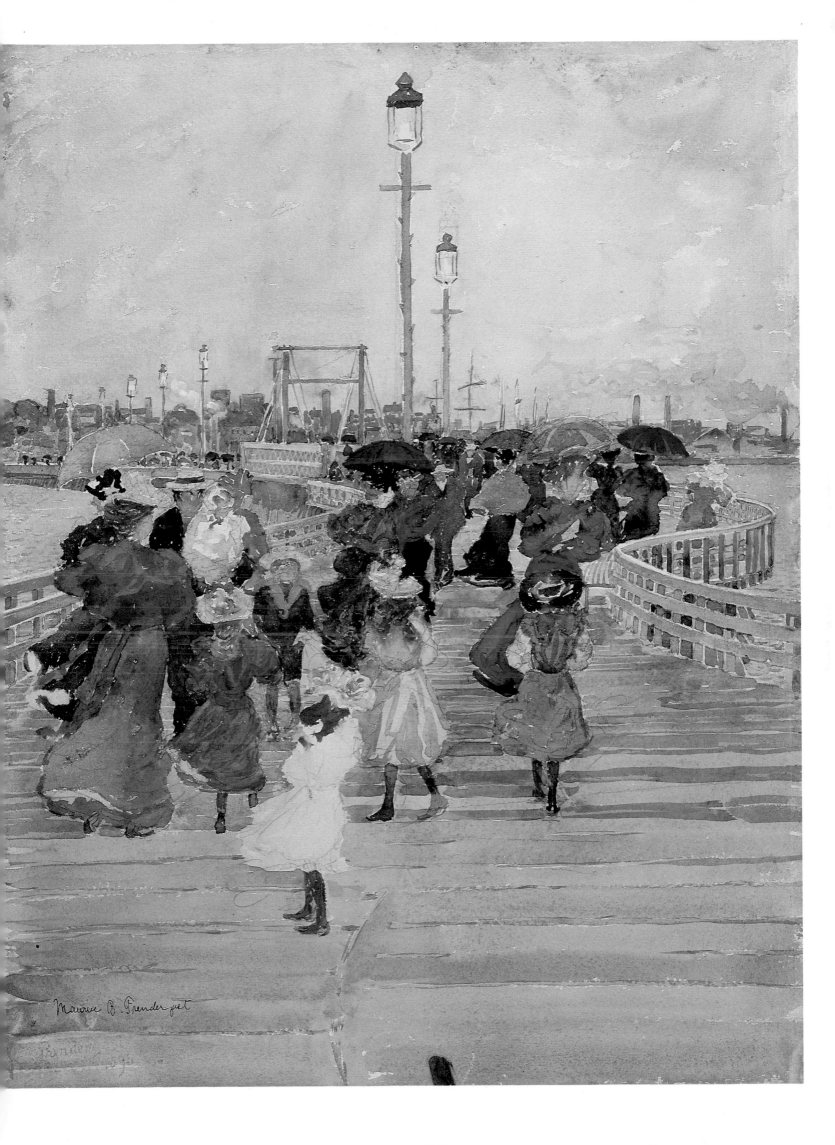

Maurice B. Prendergast

ERNEST LAWSON
1873–1939

Spring Thaw, ca. 1907

Ernest Lawson, a member of the second generation of American Impressionists, was born in Nova Scotia and raised in Ontario. He studied with John Henry Twachtman in the early 1890s, first at the Art Students League, in New York, and then in Cos Cob, Connecticut. Lawson went on to study at the Académie Julian, in Paris. He also met a member of the original Impressionist circle, Alfred Sisley.

Lawson's predilection for snow scenes and for canvases laden with layers of variegated color is an homage to his earlier mentor, Twachtman. But Lawson's handling of pigment and his brushwork were his own, and his subject matter reflected his interest in the realities of twentieth-century life. Whereas Twachtman painted locales unsullied by civilization, Lawson often painted in or near the fouled areas that modern cities gave rise to. As the *Magazine of Art* reported in 1919, Lawson could "bring beauty out of a region infested with squalid cabins, desolate trees, dumping grounds, and all the more important familiarities of any suburban wilderness." As a member of the Eight, a group of artists led by Robert Henri, Lawson rejected the genteel, academic art of the previous era, which failed to express a contemporary milieu. Though Lawson was not one of the Eight to adopt the dark realism of Velázquez, Hals, and Manet, he was like them in favoring the commonplace over the picturesque.

During the first two decades of this century, Lawson often painted in Washington Heights, a northern Manhattan neighborhood where small farms still existed alongside squatters' settlements. *Spring Thaw* belongs to a group of views of the nearby Harlem River that Lawson painted around 1907. The scene of late winter, when snows have begun to melt,

was obviously inspired by Twachtman, who had delighted in rendering subtle seasonal changes. Like Twachtman during his Greenwich period, Lawson used thick pigment and overlaid glazes, but his surfaces are richer and more plastic than his teacher's. Using a palette knife, wide brushes, and his thumb, he dragged, scumbled, and built up the paint into ridges, giving an enameled and even a sculpted appearance to the surface—the "palette of crushed jewels" often noted by art critics.

In *Spring Thaw*, the sweep of the river through the snow-covered landscape creates a strong composition. A thin web of trees, which are reflected in the water, creates a screen-like accentuation of the textured surface, but this accentuation is countered by the turquoise river's wide, graceful curve through the snow and mist. An Art Nouveau rhythm is suggested in the serpentine that is completed by the line of distant hills, and, indeed, Lawson's attention to design in this work anticipates his interest in the work of Paul Cézanne, which he would see for the first time at a seminal exhibition, the 1913 Armory Show in New York City. Touches of red contribute a soft sparkle, and give evidence of habitation, to the otherwise bleak scene. The two boats, hardly pleasure craft, underscore the loneliness of winter, and the rough beauty of a landscape not untouched by civilization.

Oil on canvas, 25 × 30 in. (63.5 × 76.2 cm). The Terra Museum of American Art, Chicago

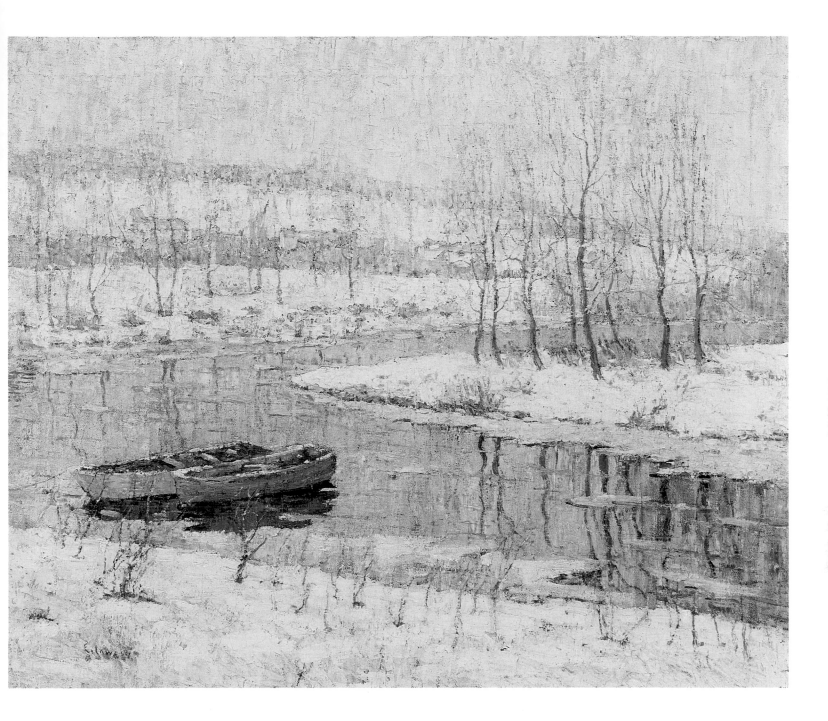

WILLIAM GLACKENS
1870–1938

The Captain's Pier, ca. 1914

William Glackens was a member of the Eight, or the Ashcan School, the group of American artists who early in this century rebelled against genteel imagery and conventional academic styles. Realist painters of great vitality, they sought to express the conditions and spirit of modern life, not the poetic reveries typical of the Boston Impressionists at the turn of the century. Like his friends John Sloan, George Luks, and Everett Shinn, Glackens began his career as a newspaper illustrator, first in his native Philadelphia and then in New York. Indeed, the dynamic style and anecdotal detail of all his oil paintings can be traced to this early phase of his career. In chronicling modern life, Glackens always found a cheerful angle, whether painting scenes of poverty or vignettes of high society.

During an 1895 stay in Paris, Glackens saw the work of Manet and Renoir. It is Manet's influence that can be seen throughout the next decade, in his broad brushstrokes, his strong tonal contrasts, and his reliance on blacks, whites, and dark greens. Glackens's allegiance changed after another trip to Europe, the purpose of which was to select French Impressionist and Post-Impressionist works for an important American collector, his friend Albert C. Barnes (these works would become the core holdings of the Barnes Foundation, in Merion, Pennsylvania). As it happened, Glackens selected a great number of Renoir's canvases for Barnes, and his own paintings soon began to reflect his new preference. He emboldened his palette with rich, hot hues, and he adopted the feathery brushstrokes associated with Renoir.

Among the m. complished of Glackens's Renoiresque works are his many beach scenes from 1911 to 1916, when he spent summers in and around Bellport, Long Island. Beaches, now easily reached by cars and trains, drew throngs of city dwellers. American Impressionists had earlier painted waves crashing on the shore and Chase had painted his family summering in solitude by the coast at Shinnecock; but Glackens painted the beach as a public spectacle. (His works are good records of the rise of the seashore as a place of recreation.) In *The Captain's Pier*, children play on the sand and mothers watch their toddlers in a Bellport scene teeming with communal activity. Also, as if to acknowledge the modern era's interest in sports and fitness, divers in black bathing suits hurtle from the end of the pier.

Renoir's influence can be seen in the celebratory spirit here, captured in the exuberant colors. As the collector A. E. Gallatin wrote in 1916, "The beach scenes, completely enveloped in sparkling and joyous sunshine, in which the figures are placed in the landscape in a most masterly manner . . . are paintings which disclose [Glackens's] genius at its best."

Oil on canvas, 32 × 26 in. (81.3 × 66 cm). Mr. and Mrs. Meredith Long

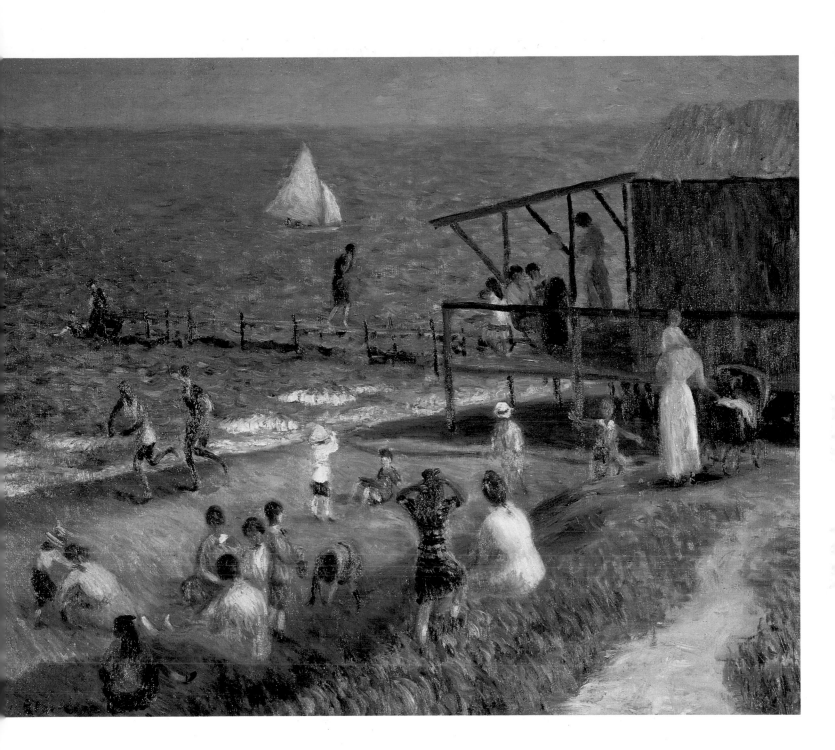

Bibliography

Atkinson, D. Scott and Cikovsky, Nicolai, Jr. *William Merritt Chase: Summers at Shinnecock, 1891–1902.* Exhibition catalogue. Washington, D.C., National Gallery of Art, 1986.

Bedford, Faith Andrews; Faxon, Susan C.; and Chambers, Bruce W. *Frank W. Benson: A Retrospective.* Exhibition catalogue. New York, Berry-Hill Galleries, 1989.

Boyle, Richard J. *American Impressionism.* Boston, 1974.

———. *John Twachtman.* New York, 1979.

Burke, Doreen Bolger. *A Catalogue of Works by Artists Born between 1846 and 1864: American Paintings in the Metropolitan Museum of Art*, volume 3. New York, 1980.

———. *J. Alden Weir, An American Impressionist.* Newark, Delaware, 1983.

Chotner, Deborah; Peters, Lisa N.; and Pyne, Kathleen A. *John Twachtman: Connecticut Landscapes.* Exhibition catalogue. Washington, D.C., National Gallery of Art, 1989.

Clark, Carol; Mathews, Nancy Mowll; and Owens, Gwendolyn. *Maurice Brazil Prendergast, Charles Prendergast: A Catalogue Raisonné.* Williamstown, Massachusetts, 1990.

Curry, David Park. *Childe Hassam: An Island Garden Revisited.* New York, 1990.

de Veer, Elizabeth, and Boyle, Richard. *Sunlight and Shadow: The Life and Art of Willard L. Metcalf.* New York, 1987.

Fairbrother, Trevor J. et al. *The Bostonians: Painters of an Elegant Age, 1870–1930.* Exhibition catalogue. Boston, Museum of Fine Arts, 1986.

Ferguson, Charles B. *Dennis Miller Bunker (1861–1890) Rediscovered.* Exhibition catalogue. New Britain [Connecticut] Museum of American Art, 1978.

Fort, Ilene Susan. *The Flag Paintings of Childe Hassam.* Exhibition catalogue. Los Angeles County Museum of Art, 1988.

Gerdts, William H. *American Impressionism.* Exhibition catalogue. Seattle, University of Washington, Henry Art Gallery, 1980.

———. *American Impressionism.* New York, 1984.

———. *Down Garden Paths.* Exhibition catalogue. Montclair [New Jersey] Art Museum, 1983.

Gerdts, William H. et al. *Ten American Painters.* Exhibition catalogue, New York, Spanierman Gallery, 1990.

Getlein, Frank. *Mary Cassatt: Paintings and Prints*, New York, 1980.

Hale, John Douglass; Boyle, Richard J.; and Gerdts, William H. *Twachtman in Gloucester: His Last Years, 1900–1902.* Exhibition catalogue. New York, Spanierman Gallery, 1987.

Hills, Patricia et al. *John Singer Sargent.* Exhibition catalogue. New York, Whitney Museum of American Art, 1987.

Hoopes, Donelson F. *The American Impressionists.* New York, 1972.

———. *Childe Hassam.* New York, 1979.

Johnston, Sona. *Theodore Robinson, 1852–1896.* Exhibition catalogue. Baltimore Museum of Art, 1973.

Love, Richard H. *Theodore Earl Butler: Emergence from Monet's Shadow.* Chicago, 1985.

Lowrey, Carol. *Philip Leslie Hale, A.N.A. (1865–1931).* Exhibition catalogue. Boston, Vose Galleries, 1988.

Mathews, Nancy Mowll. *Mary Cassatt.* New York, 1987.

———. *Maurice Prendergast.* Exhibition catalogue. New York, Whitney Museum of American Art, 1990.

Ormond, Richard. *John Singer Sargent.* New York, 1970.

Peters, Lisa N. et al. *In the Sunlight: The Floral and Figurative Art of J. H. Twachtman.* Exhibition catalogue. New York, Spanierman Gallery, 1989.

Pisano, Ronald G. *A Leading Spirit in American Art: William Merritt Chase, 1849–1916.* Exhibition catalogue. Seattle, University of Washington, Henry Art Gallery, 1983.

———. *William Merritt Chase.* New York, 1979.

Pollock, Griselda. *Mary Cassatt.* New York, 1979.

Spencer, Harold; Larkin, Susan G.; and Andersen, Jeffrey W. *Connecticut and American Impressionism.* Exhibition catalogue. Storrs, University of Connecticut, 1980.

Sellin, David. *Americans in Brittany and Normandy, 1860–1910.* Exhibition catalogue. Phoenix Art Museum, 1982.

Wilmerding, John; Dugan, Sheila; and Gerdts, William H. *Frank W. Benson: The Impressionist Years.* Exhibition catalogue. New York, Spanierman Gallery, 1988.

Index

Editorial and production services by Harkavy Press

SENIOR EDITOR: DALE RAMSEY

PICTURE EDITOR: LUCY BARBER

COPYEDITOR: JULIE SMITH

DESIGNER: BETTY BINNS/BINNS & LUBIN

INDEXER: CHARLES CARMONY

Photography